PAINTING
IN THE OPEN AIR

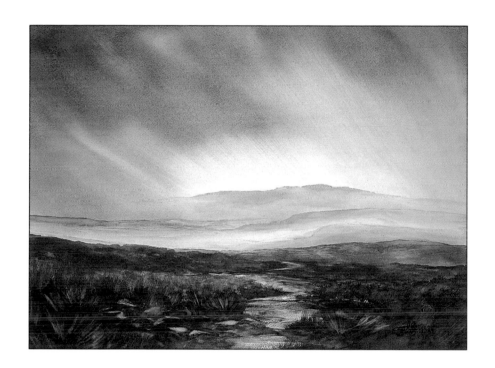

Ashley 979 F.R.S.A.
ANJ

PAINTING
IN THE OPEN AIR

Ashley Jackson

ATMOSPHERIC LANDSCAPES
IN WATERCOLOUR

HarperCollins*Publishers*

DEDICATION

I dedicate this book to Anne, my wife, and
Heather and Claudia, my daughters, with
thanks for the love, help and understanding
that they have shown to me throughout
the years I have striven within the world of
art; and to my beloved Yorkshire.

ACKNOWLEDGEMENTS

I would like to thank Janice Foxton for
patiently typing my words for this book,
Stewart Coxhead for his help in editing,
Malcolm Howarth for the photography,
and also Cathy Gosling and Caroline
Churton at HarperCollins for giving me all
the help and support that I have needed.

First published in 1992 by
HarperCollins*Publishers*
London

© Ashley Jackson, 1992

Art editor: Caroline Hill
Designer: Isobel Gillan
Photographer: Malcolm Howarth

**A CIP catalogue record for this book is available
from the British Library**

ISBN 0 00 412607 6

Set in Meridien by
Phoenix Photosetting, Chatham, Kent
Originated, printed and bound in Hong Kong by
HarperCollins*Publishers*

TITLE PAGE: *Wild Moor,
Yorkshire*, Saunders
Waterford 140 lb
Rough, 50 × 75 cm
(20 × 30 in)

CONTENTS

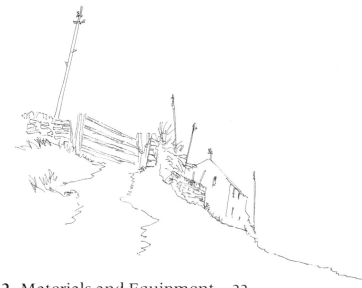

PORTRAIT OF THE ARTIST

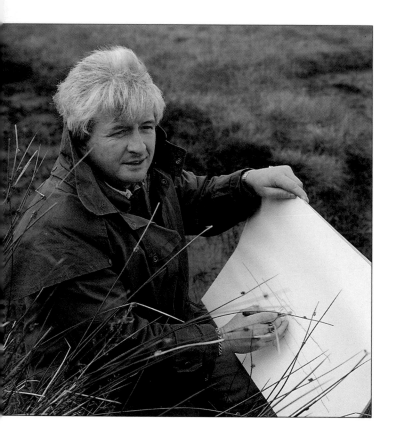

Ashley Jackson never actually set foot in England until he was ten years old. He spent the first ten months of his life in Penang, Malaysia, and was then evacuated with his mother to India. On the death of his father in a Japanese prisoner-of-war camp, the family moved first to Scotland and then back to Penang. It was only when his mother remarried that the family settled in Yorkshire.

This was the start of Ashley's life-long love affair with Yorkshire, as the Pennines began to hold him in their grip. It was at that time that his interest in art, first noticed some years previously, was encouraged and developed. On leaving school, he studied at Barnsley Art School for a year before becom-ing apprenticed to a local sign-writer, Ron Darwent. Despite the fact that Ashley's spelling led to some unfortunate but sometimes amusing incidents, this job provided a period of stability and resulted in a close and lasting friendship. It was also during this time that Ashley met and married his wife Anne.

Ashley's love of painting never left him, however, and he constantly sought to capture in his watercolours the atmosphere of the wild Yorkshire landscape, with its sense of desolation and austere beauty. At his first one-man exhibition in Brighouse, Yorkshire, he sold half the paintings on dis-play, making quite an impression on the local art scene in the process. As the sales of his paintings steadily increased he decided to take the plunge and become a full-time, pro-fessional artist. In 1967 he was elected a Fellow of the Royal Society of Arts.

He opened his first gallery in Barnsley in 1968 and eventually achieved wider recog-nition with a one-man exhibition in London. The highlight of his career at this time was the occasion when L. S. Lowry walked through the doors of his gallery and subsequently purchased one of Ashley's paintings. The two artists became close com-panions thereafter and Ashley regularly had afternoon tea with Lowry at his home. This was an honour, indeed, for Lowry was regarded as something of a recluse; yet he took a keen interest in Ashley and his work, offering both practical advice and constant encouragement.

Since then Ashley's work has been widely exhibited throughout Britain and the USA, as well as in Europe. His atmospheric watercolours are to be found in many pri-vate and public collections, and several tele-

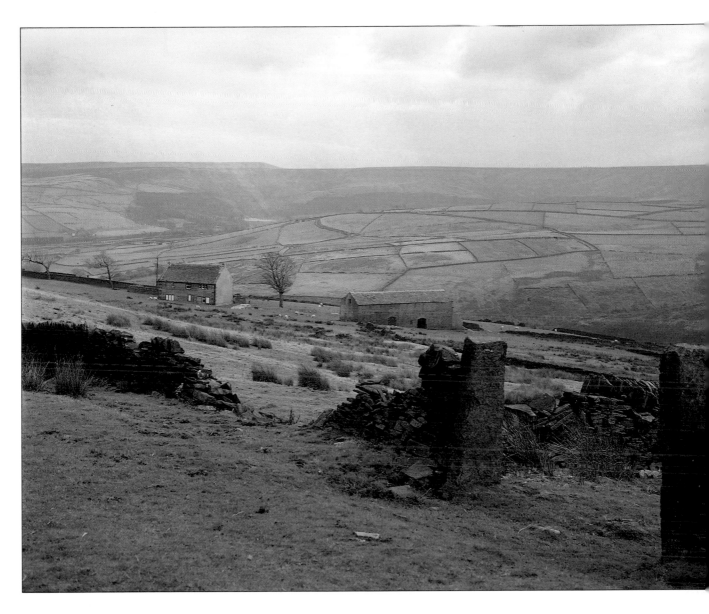

Bradshaw Moor, near
the author's home

vision programmes have introduced him to an even wider audience.

Although painting remains Ashley's first love, he devotes much of his time to his other interests, including environmental issues, which have always been a major concern of his. He is also heavily involved with The Prince's Youth Business Trust and is a dedicated fund-raiser for the charity.

Ashley Jackson lives in Holmfirth, Yorkshire, with his wife and their two daughters, in a house on a hill with a spectacular view of the surrounding countryside. He is seldom happier than when he is out on the moors, in all weathers, painting the dramatic Yorkshire landscape he loves so much.

INTRODUCTION

For as long as I can remember, I have been conducting a love affair – a veritable *ménage à trois* – with Mother Nature and a small box of magic, namely my watercolour paints. This love affair has allowed me to travel around the world, to meet some wonderful people and, hopefully, to give a little pleasure to others through the medium of painting.

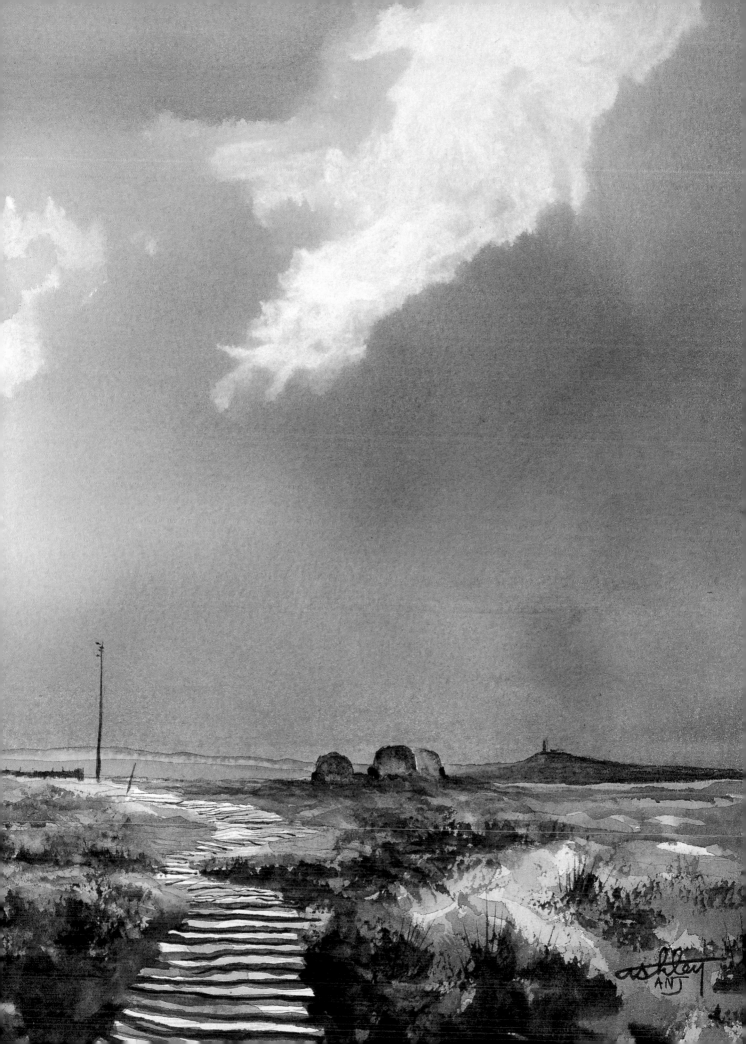

In this book I would like to share with you some of my experience, joy and knowledge gained over many years as an artist. We are all blessed with certain gifts – some of us communicate through music, some through the written word; I just happen to be at my best clutching a handful of brushes, a palette loaded with colour, and a sheet of fresh white paper just waiting to portray the fruits of my imagination.

I was brought up as a working-class lad from Barnsley in South Yorkshire, where a career as an artist was thought of by my peers as something rather dubious. Even I used to think that only the upper classes had the right to take up a brush and paint. How silly that early impression was. Painting is a gift from above, for everyone – farmer,

PREVIOUS PAGES: *Paths That Cross the Pennines*, Saunders Waterford 140 lb Rough, 50 × 75 cm (20 × 30 in) (By kind permission of Eltec Computers)

OPPOSITE: Ashley Jackson drawing on Saddleworth Moor, Yorkshire

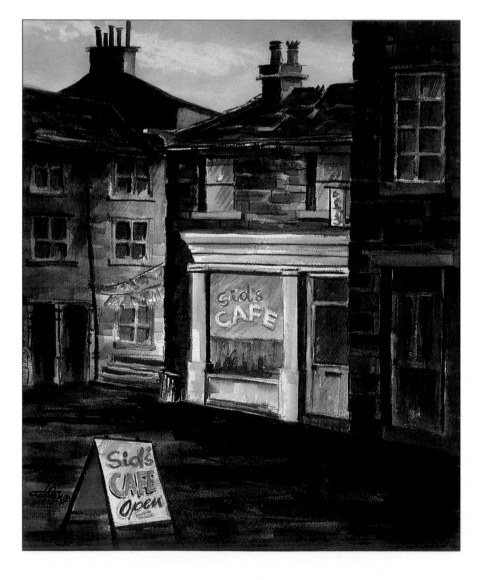

In Memory of Sid, Holmfirth, Saunders Waterford 140 lb Rough, 50 × 75 cm (20 × 30 in) (By kind permission of Alan Bell, BBC Television)

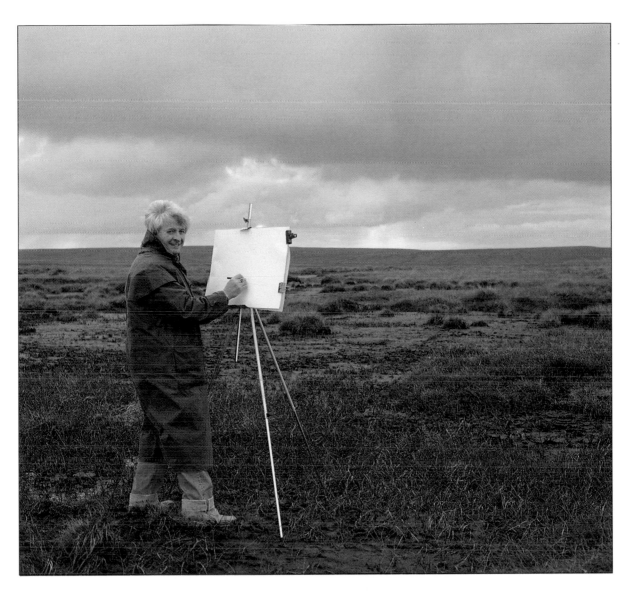

factory worker, landowner, or those without employment. It should know no social, religious or racial barriers, nor should it attempt to create standards. You should be the sole judge of your own work; as long as you like the finished painting, that should be satisfaction enough.

In order to be a 'real' landscape artist, you need to experience nature at first hand: to feel the atmosphere of the landscape all around you; to be aware of the open space, the wind and the light in natural surroundings. Of course, you can paint anywhere, but without that first-hand experience of the countryside, all you will achieve is a picture, a mechanically constructed image. A painting is not only about technique; it also con-

tains a little of the very soul of the artist. L.S. Lowry, the famous Lancashire artist, once said to me, 'The best way to paint the landscape is to get out and get into it.' I absolutely agree with this. It is of no value learning how to swim on dry land; the only way to learn properly is in the water, tasting the salt, feeling the waves all around you. It is just the same with landscape painting; you must experience the countryside around you in all its moods before you can paint it.

The wonderful thing about painting is that it expresses in paint what cannot always be said in words, and it does so in a language the whole world understands. I hope the following chapters will help you to learn and enjoy that language yourself.

1 USING YOUR SENSES

When painting in the open air all your major senses come into play. Hearing, smell and touch, as well as sight, all play a vital part in the overall outdoor painting experience and should be savoured to the full so that they contribute that special magic ingredient to your work.

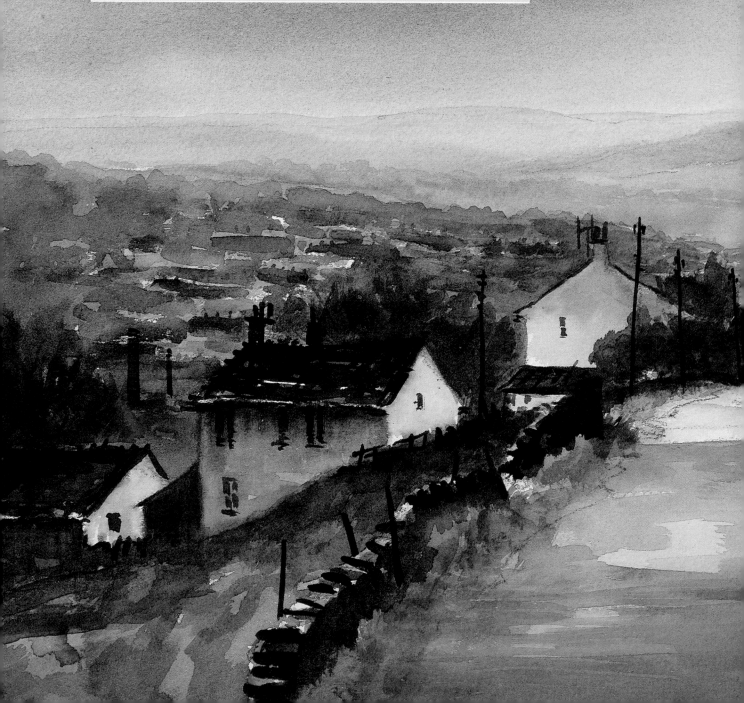

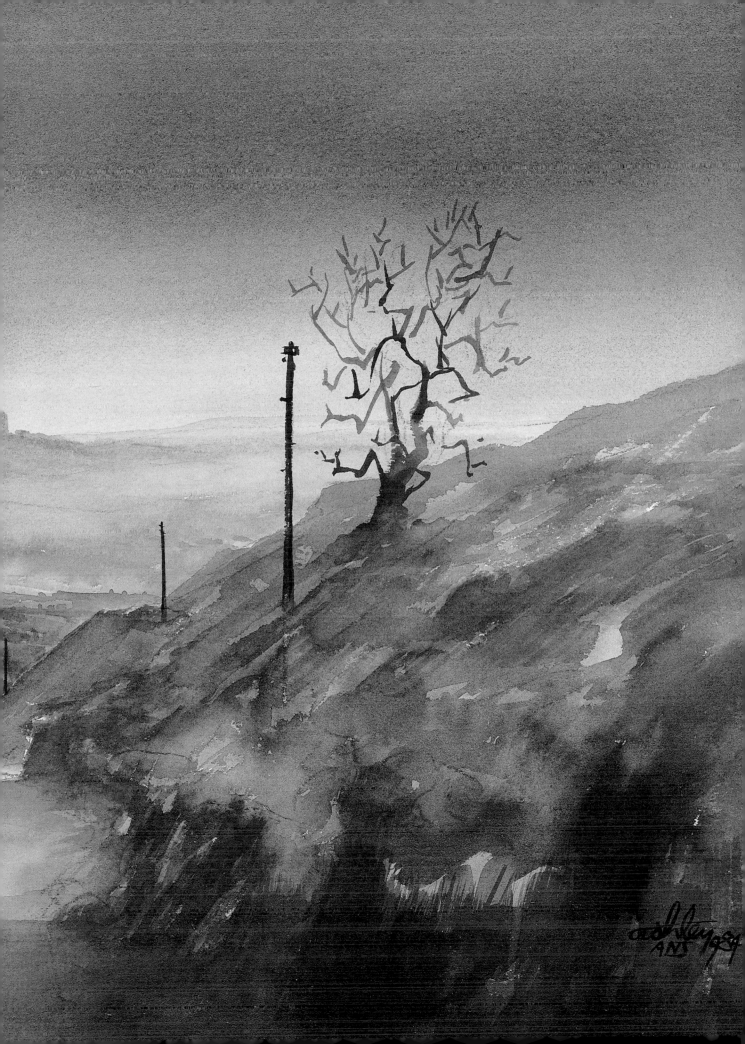

I have called this book *Painting in the Open Air* because to me there is no finer studio than the one nature provides free and for everyone. It is, of course, possible to create very good-quality work in a studio, but for me personally the excitement and inspiration I get from standing on some lonely mountain or rugged shoreline cannot be captured in studio conditions.

As I walk out on my favourite moors I constantly see dozens of potential paintings and numerous angles from which to paint them. So how do I choose my subject? Well, in my case it is easy. Having allowed all my senses to be completely enveloped by the atmosphere, I am extremely aware of and alert to my surroundings. When that special scene comes along, I actually feel the hairs on the back of my hands stand on end. That's when I pick up my brush and paint. It is as if I have let nature choose her own subject.

Although I have painted many 'warm weather' scenes in my life, sunshine and blue skies do not appeal to me as much as dramatic skies and windswept moorlands. Filtered light and rain can create an eerie quality and I suppose it is really the atmospheric character of the land on such days that attracts me to paint in these conditions.

Having said that, I recently visited the place of my birth, Malaysia, where the sun shines ferociously and you live in 'three shirts a day' humidity, and I really enjoyed painting scenes with heat haze instead of mist, using bright oranges and reds rather than my usual melancholy blues and greens. By absorbing the atmosphere of the place I was able to portray the very different character of a hot country in my painting.

PREVIOUS PAGES:
Holmfirth from Cartworth Moor, Saunders Waterford 140 lb Rough, 50 × 75 cm (20 × 30 in)

Teluk Bahang, Penang, Malaysia, Saunders Waterford 140 lb Rough, 50 × 75 cm (20 × 30 in)

14

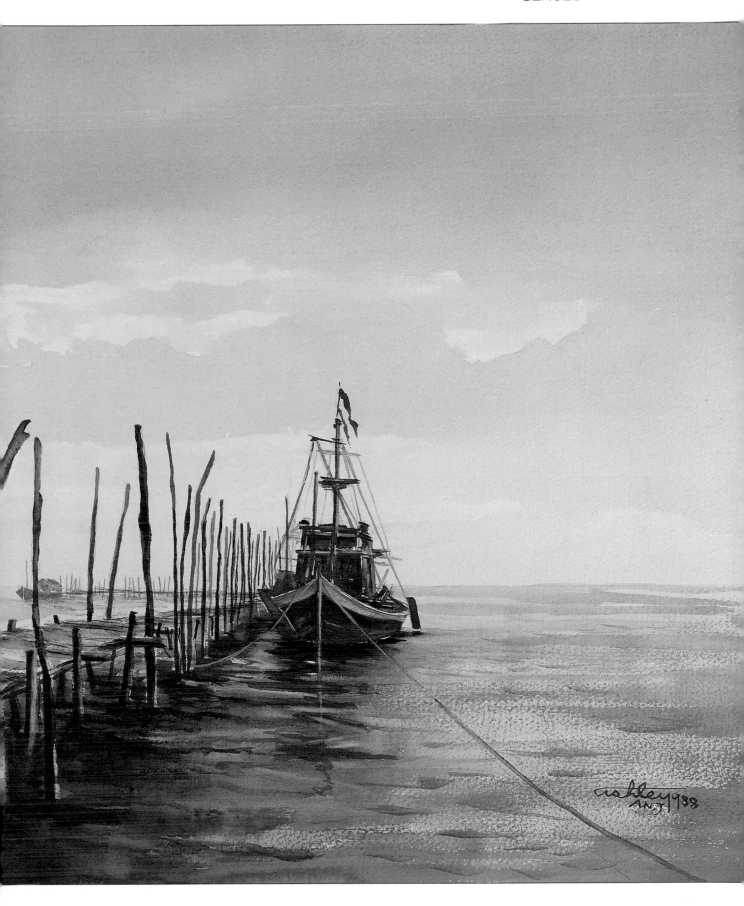

It is a long way from the warm beaches of Penang to a cold, Scottish glen, but the same rules apply when coming to paint it. Let the atmosphere of the surroundings soak into your senses before you even start to look for the perfect picture. Once you feel 'in tune' with the landscape around you, your painting will start to come alive.

There are many people who have never had the benefit of sight, something most of us take for granted. However, the blind develop their other senses to compensate for their lack of sight. For artists, too, developing these other senses is every bit as important as relying primarily on their sense of sight to view a scene and copy it. Only when all your senses combine to create your work will you achieve a painting, not simply a picture.

OPPOSITE: *Lighthouse, West Coast, Oregon,* Saunders Waterford 140 lb Rough, 50 × 75 cm (20 × 30 in)

BELOW: *Birds on West Nab, Yorkshire,* Saunders Waterford 140 lb Rough, 50 × 75 cm (20 × 30 in)

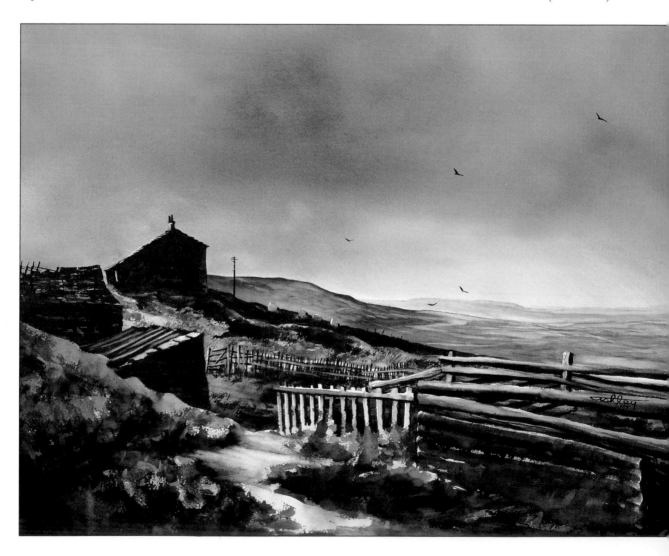

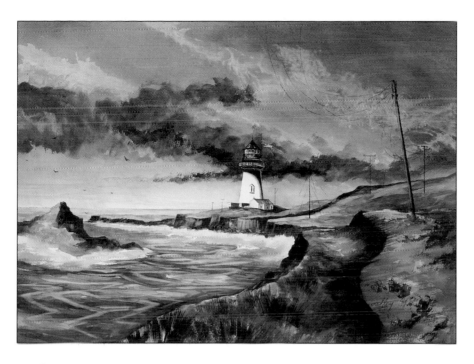

Sight

Sight, for the artist, is about really learning to observe: to see, not simply to look; to interpret rather than merely copy. Sight enables you to pick out the most important aspects of a scene and make the viewer's eye fall on those particular elements by emphasizing their presence. Sight allows you to observe the direction of light on your work, to note where light and shadows fall, and to see what effect this has on the colours in the landscape. Sight allows you to interpret tone and depth, and to assess the overall composition of your landscape. Use your eyes like a film director uses his camera lens, carefully checking all the elements of the scene before going for a 'take'. I am forever painting pictures in my mind, practising my powers of observation and imagining how I would portray what I see when actually starting to paint.

Hearing

Hearing is perhaps the sense that most easily provides inspiration. Out in the countryside, the sound of the whistling wind, the splattering of raindrops, the noise and drama of thunder and lightning all have immense inspirational qualities. On a calm day, too, the pleasant noises of animals and the lovely sound of birdsong create a peaceful, content atmosphere. I think of these things as the 'music of the moor' and always try to reflect this in my paintings.

Touch

Touching is a form of communication and I often pick up blades of grass, twigs, soil and rocks in the countryside so that I can learn about their shape, form and texture. You can also feel less substantial elements of the landscape, such as driving rain or rushing water in a stream, and the bite of a chilly wind or the heat of the sun. This knowledge is invaluable to me when portraying these things in my paintings. It adds a reality to my work that I could not otherwise achieve.

17

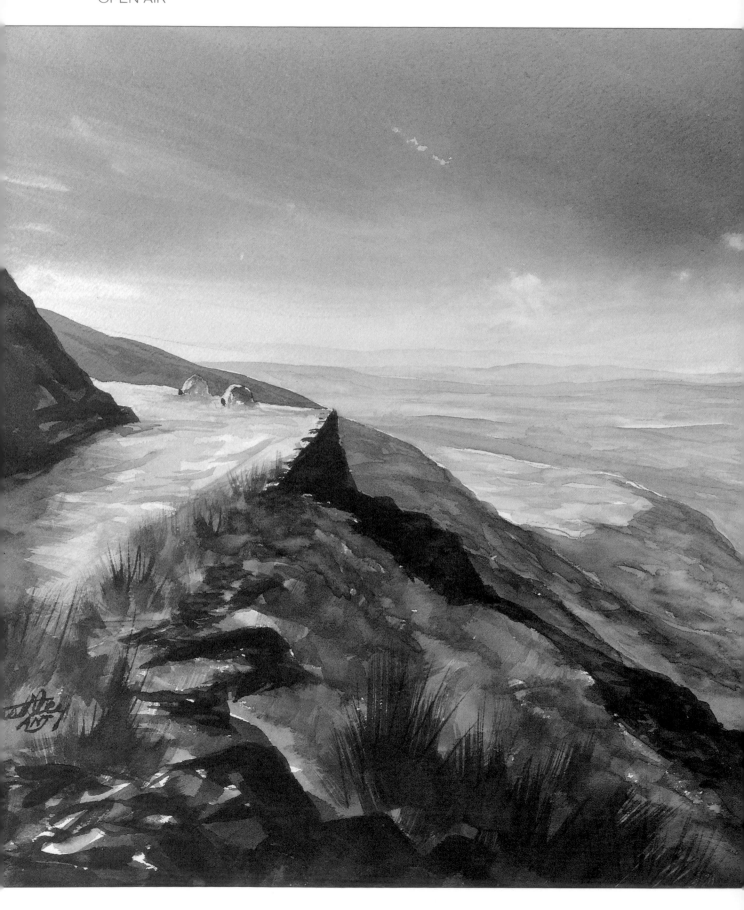

Smell

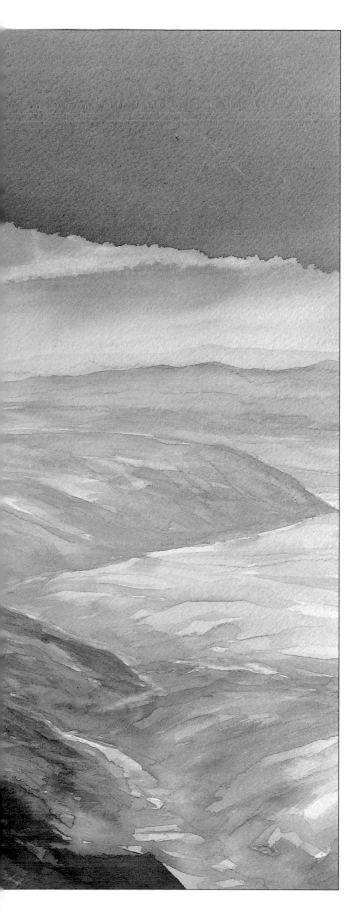

The smells of the landscape are very evocative: the fragrance of wild flowers, heather and bracken; the saltiness of the sea; even the distinctive smells of the different seasons. Smelling can also be an aid to seeing colours more accurately. Imagine, for example, trying to paint a view containing the entrance to a railway tunnel. When you approach a tunnel, your first impression is one of colour – dark blues and indigos for the interior, dark browns for the earth. Suddenly, your sense of smell takes over; you smell the dampness and the fustiness of the tunnel's interior. Because the sun has never penetrated its depths, the tunnel remains earthy and dank, with the smell of newly dug potatoes. Use that sensory experience when you start to paint; make the interior of your tunnel dank and earthy, so that people who view your work will pick up on that smell. I habitually say to my friends, often to their amusement, 'If you can't smell it, you can't paint it.'

*Wessenden Moor and
Valley*, Saunders
Waterford 140 lb
Rough, 50 × 75 cm
(20 × 30 in)

Getting to know your landscape

I would like to share with you a little bit of knowledge that I have gained over the years concerning the humble grass sod. If you paint regularly, you probably do not travel a very great distance from your home to do so, other than when on holiday, and therefore you know the terrain, the weather conditions, and the types of trees and other features within your own area very well. You do not have to evaluate their colours because they are as familiar to you as your own back yard, and painting them becomes second nature to you. But what happens if you live in one part of the country and want to paint in another? The landscape of Yorkshire, for example, is very different from that of Cornwall, and the Lincolnshire fens are nothing like the Lake District. You will find that all the colours you would normally mix on your palette have changed. Enter the grass sod!

Whenever I am out painting in an unfamiliar area, I use a small spade which I always carry in the back of my car, to dig up a sizeable sod of earth, being very careful to return it whence it came after use. Try this yourself. Holding the sod up to the light, you will see that all the colours of the landscape around you, layer upon layer of them, are contained in the sod, telling you what colours to mix for your painting. The fields, the riverbanks, the roads, the trees, even the houses, all come from the earth and therefore all contain the basic colours of that sod. This is illustrated in the small still life of a house, trees, wood and hillside in Fig. 1. See how the colours of all these features can be found in the grass sod. Wherever you are in the world, a piece of local earth, dug up and studied, will tell you specifically all you need to know about the particular environment that you wish to paint. I often put my grass sod into a polythene bag and take it back to my hotel to study it carefully. It is like having a guide to the perfect palette.

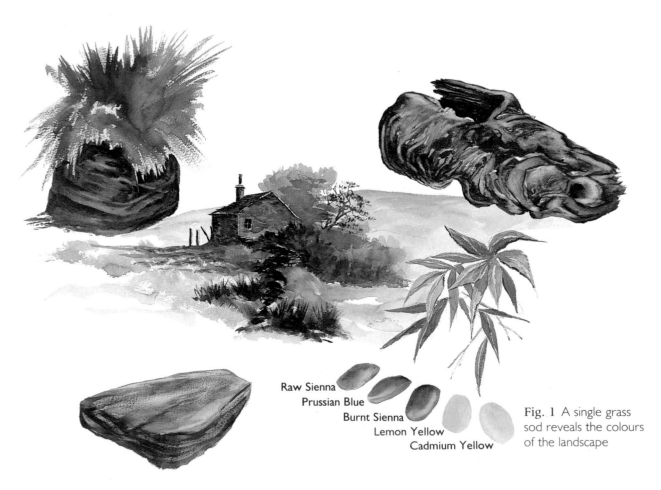

Raw Sienna
Prussian Blue
Burnt Sienna
Lemon Yellow
Cadmium Yellow

Fig. 1 A single grass sod reveals the colours of the landscape

RIGHT: **Fig. 2** Dry
wood, stone and peat

FAR RIGHT: **Fig. 3** Wet
wood, stone and peat

RIGHT: **Fig. 4** Dry
moorland

FAR RIGHT: **Fig. 5** Wet
moorland

I also recommend collecting and studying other examples of nature – a small piece of discarded wood, a stone from a dry-stone wall, peat from a peat bog. Notice how on a sunny, warm day all the colours of such objects harmonize: the stone is a soft grey, with a little Raw Sienna in it; the wood is also the colour of Raw Sienna; and the peat contains Burnt Sienna (Fig. 2).

When the weather is wet, however, the same objects change colour. They take on richer, deeper tones, and glisten instead of appearing dull. Raw Sienna and Raw Umber become Burnt Sienna, and Burnt Sienna becomes Burnt Umber. Try splashing a little water onto these objects and observe how it alters their colours (Fig. 3). See how flat and subdued the colours of the dry moorland in Fig. 4 are compared to the more vibrant tones of the landscape when wet (Fig. 5).

Painting in the open air is as much about the open air as it is about painting. Before you even unpack your paint box, or erect your easel, go out and let your shoes sink into the moorland peat, feel the damp seep-

ing through your socks, walk into an old barn and smell the musty odours and the dampness due to the lack of light. Take hold of a piece of dry-stone wall, feel its weight, shape and texture. Run your fingers over the bark of trees. Pick up twigs and see how they are formed. Once you understand nature's design techniques, you will improve your own ten-fold.

When I look at farms and houses I also try to imagine the generations of people who have lived, prospered, suffered, loved, hoped, despaired and even died there. This helps me to portray something of the character of the place, rather than simply painting a functional building.

Use every sense you possess to trawl as much knowledge and feeling about the landscape as you possibly can. Believe me, whatever you can absorb in this way will transmit powerfully to your painting when you are ready to commit yourself completely. Only then will you find that you stop painting pictures and instead begin to paint paintings.

2 MATERIALS AND EQUIPMENT

Buying materials and equipment sensibly and correctly at the outset will give you confidence in your work and will help you to achieve better paintings. Remember that cheap materials will give you cheap results.

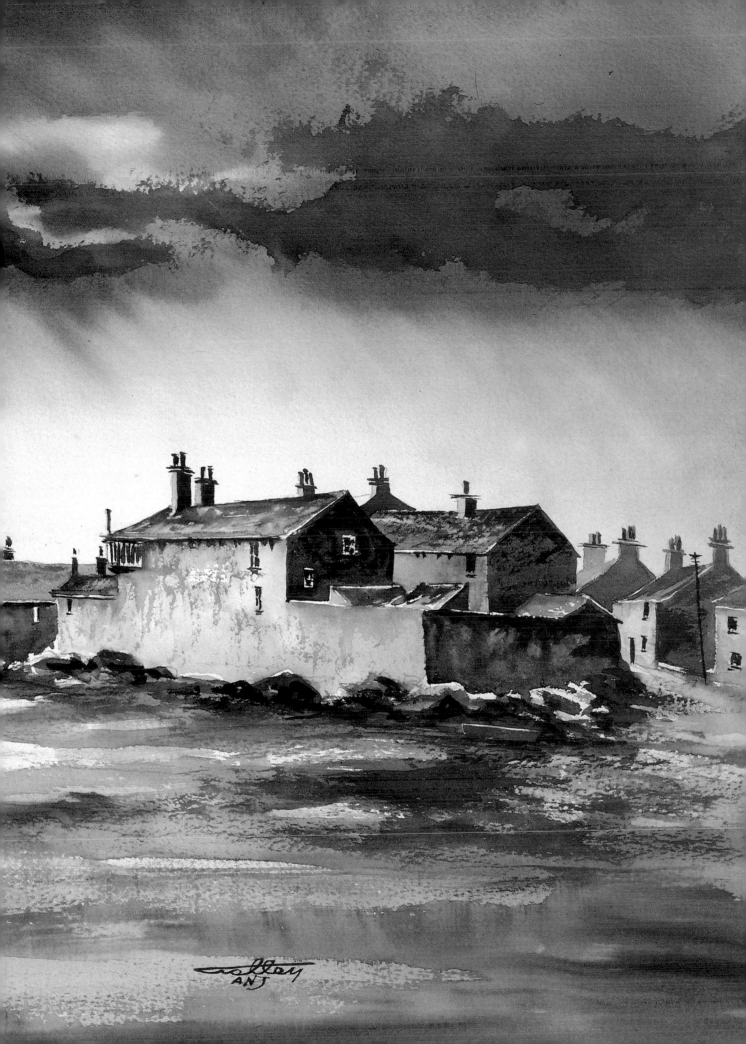

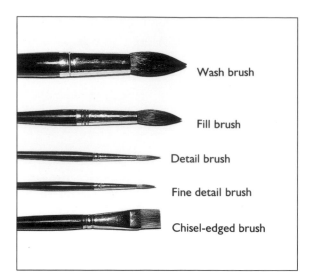

Wash brush

Fill brush

Detail brush

Fine detail brush

Chisel-edged brush

Fig. 6 A selection of basic watercolour brushes

People often assume that the materials used in watercolour painting are cheaper than those required for oil painting. Unfortunately, this is not true; whilst painting as a hobby is not wildly expensive, it does involve some cost. Nevertheless, it pays great dividends to use good-quality paper, paints and brushes.

Brushes

Watercolour brushes come in a range of sizes and shapes for a variety of effects, but good brushes all have several things in common. The brush handle should be comfortable to hold and use. The ferrule, which is the metal piece that clamps the hairs to the handle, should be of a material that will not rust, and should be firmly fastened to the handle. Before you buy, check the brush by trying to wiggle the ferrule. If it moves at all, try another brush. Best of all are nickle-plated ferrules that are double-crimped for security. The hairs of your brush should be natural animal hairs, because they hold the water better than synthetic fibres. Brushes can be made of anything from synthetic materials to pony, ox, squirrel or goat tail hair, but the Rolls Royce of brushes is the Kolinsky sable. You would need to take out a second mortgage to buy a full set of these sable brushes, but they do give you absolute control on the paper. Purchase what you can afford, but try to stay away from synthetic brushes. My brushes are made from the hair of the Manx cat! Also remember to look for brushes that taper cleanly, either to a point for your round brushes, or to a chisel edge for your flat brushes.

Fig. 6 illustrates the basic watercolour brushes. You should always start your paintings with a large brush: if you use a small brush to begin with you will find you never put it down and your work will become too detailed.

PREVIOUS PAGES:
Ravenglass, Cumbria,
Saunders Waterford
140 lb Rough,
50 × 75 cm (20 × 30 in)

Wash brush

The wash brush, such as Daler-Rowney's Series 66, is the biggest of the brushes. It can hold a great deal of liquid and is used for covering large areas of paper with paint or water, and for painting more impressionistic areas of your composition. It is excellent for painting sky and water, as well as for wiping out colour, as when creating clouds (see Chapter 3).

Chisel-edged brush

The chisel-edged brush is a flat brush with short bristles. When moistened it forms a beautiful straight edge. Using the brush vertically and horizontally, you can achieve a variety of wide and narrow strokes. It can be used effectively to put in fences, hedges, telegraph poles, cliff sides and buildings, and it is ideal for wiping out thin areas.

Round brushes

Round brushes come to a fine point when wet and are available in varying sizes. Useful sizes include the fill brush (No. 14), detail brush (No. 5), and fine detail brush (No. 3). The fill brush, which is the largest of this family, holds a quantity of paint and is used for less detailed, longer strokes where you do not want to have to reload your brush too often. The detail brush, as its name implies, is most often used for placing detail into a painting. It gives a stroke of medium width and holds somewhat less paint than the fill brush. The fine detail brush is the smallest of the round brushes. When wet, it tapers to a very fine point. Because of its size, it holds only a small quantity of paint and is used when very fine detail and short lines are needed. Twigs, blades of grass, window panes and the artist's signature are often painted with a fine detail brush.

Care of your brushes

To clean your brushes, simply swirl them in clean water to remove all pigment, then draw them through your fingers to eliminate excess water and restore their original shape. It is not a good idea to leave them standing in water. Lay your brushes flat to dry. Do not up-end them in a pot as this can allow water to collect in the ferrule, leading to damage.

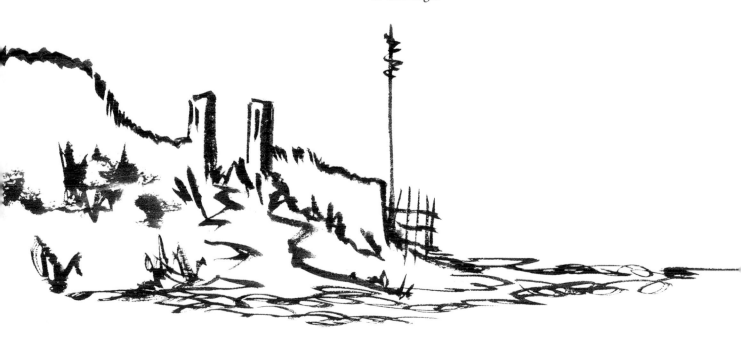

Fig. 7 Metal
watercolour palette

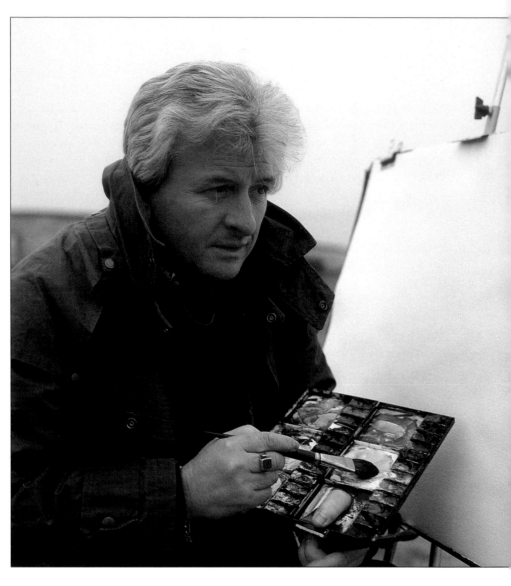

Paints

Most of us are familiar with the little hard cakes of watercolour paint that children use, but it is difficult to get a good, consistent mix with these and so they should be avoided. Watercolour artists generally prefer to use good 'artist quality' tube paints which mix more easily. Look for paints with a working texture that is smooth, not runny or grainy. You should be able to mix the paint without it beading or separating. The colour should be strong, because you will find that watercolour tends to dry about 50 per cent lighter than it appears when wet, and it should have a good to excellent light-fastness rating, so that your finished painting will not fade over time. I recommend Daler-Rowney's Artists' Watercolour range and the main colours that I use in this book are illustrated on page 51. Although Chinese White paint is available, I never use it because I paint in the English school of watercolour painting, where the whiteness of the paper forms the white areas of the painting.

One of the virtues of tubed watercolours is that you can squeeze out just the amount of paint you need. You will soon be able to judge this with a little experience. If you do have paint left over, however, it does not hurt to let it dry on your palette; just moisten it again when you are ready to use it.

Palettes

Although you may have satisfactorily used cups and saucers for mixing your paints, nothing is nicer than having a watercolour palette especially designed for the work you are doing. This palette should have a generous number of slots to hold your colours and keep them separate, as well as several large mixing wells. Ideally, the palette should be metal and not plastic. Plastic surfaces allow the pigment to bead, causing it to slide around the palette, and you can spend half your time chasing the mix around! Plastic palettes also stain badly with use and therefore make colour mixing more difficult. My favourite type of palette is a metal one with an enamel-coated surface. When I buy a new one, I use an abrasive powder to roughen the enamel slightly, as this allows the paint to adhere to the surface better and it is therefore easier to control when mixing. Because I paint outside a good deal, where there is often no place to set things down, I prefer a palette I can hold in one hand whilst painting with the other (Fig. 7). To clean your palette, simply wipe it with a wet paper towel.

Paper

The paper you choose for your watercolour painting is vital to your success. Many beginners use cheap paper to practise on, saving their better paper for their 'good' work. This is counter-productive, however, because the results achieved when struggling with a poor-quality paper will be quite different from those possible when working on better-quality paper. For example, a lightweight paper will buckle and warp severely when wet, making it difficult to paint on; and because you will never be able to get it to lie flat again, you will find it impossible to frame properly. The surface of a lighter paper also tends to peel and ball up, creating blemishes when you try to wipe out and

rework. I advise you to do all your painting on good-quality paper and so avoid these problems.

The weight, texture and content of your paper are all very important factors. Watercolour paper should be at least 140 lb in weight. It should not then need to be soaked or pre-stretched, and should lie flat when attached to a painting board with clips. Another advantage of heavier paper is that it is sturdy enough to allow you to paint on both sides, making it economical for practice work as well.

There are three different textures of watercolour paper available: Hot Pressed, Not (or Cold Pressed) and Rough. You should avoid Hot Pressed paper, which has a smooth finish that does not hold the paint easily, making it harder to control. Not, or Cold Pressed, paper has more texture, allowing better control of paint and greater absorption for more brilliant hues. Rough paper has a coarser surface and is best for less detailed work, making it ideal for the outdoor painter.

I use Saunders Waterford 140 lb Rough for preference. Make sure that the paper you choose is double-sized (impregnated twice with sizing) so that you will be able to wipe out and otherwise work with it without damage to the surface.

Always use an acid-free rag blend, never wood-pulp paper. Acid-free paper will not discolour with age and therefore will protect and extend the life of your treasured works of art.

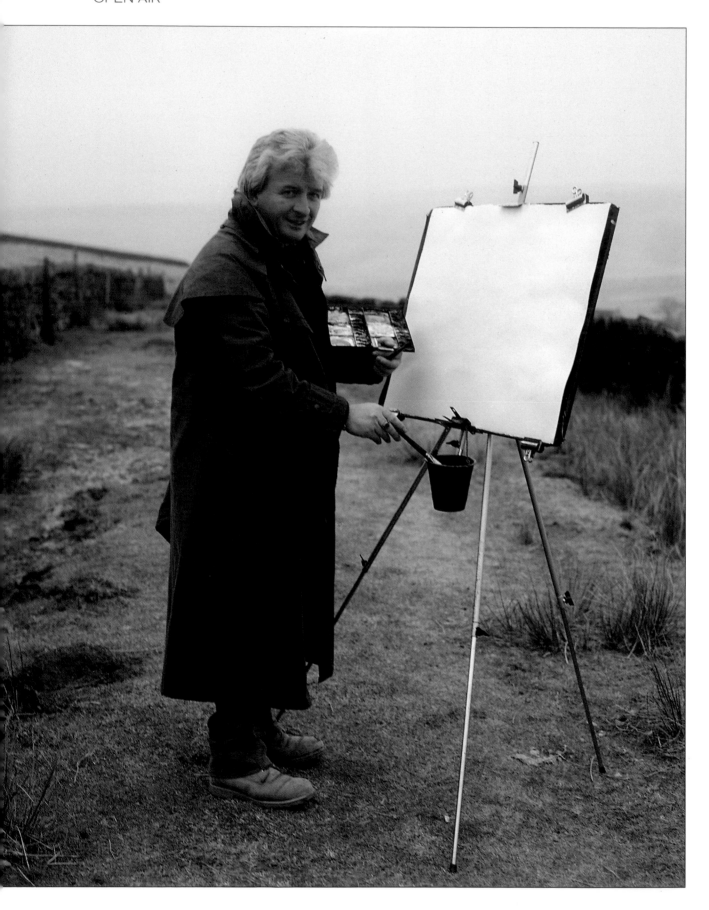

Miscellaneous items

In addition to the important materials that I have already mentioned there are a few other items that you will need. You should carry some sketching pencils. These should have very soft leads so that you will be able to draw good images using only a light touch: it is important to avoid leaving indentations in your paper which might subsequently show up when watercolour is applied. A soft lead will also lift off more easily if you need to make changes. I recommend 4B pencils and use them half size. Any erasures should be made with an extra-soft eraser that will not harm the surface of your

OPPOSITE: **Fig. 8** Metal
tripod easel

BELOW: **Fig. 9** Ashley
Jackson's artbin

paper. Hard erasers, such as those found on the end of writing pencils, can damage a painting permanently. A putty eraser is a good choice.

If you are using a heavy, good-quality paper, a board and clips are all you will need to hold it. The board should be water-resistant and only slightly larger than the paper, so that this can be clipped to it. Make sure that your clips are strong enough to hold the paper without slippage. You will also need an easel to put your board on. I use a standard Daler-Rowney metal tripod easel with adjustable legs so that it stays firm when I am painting outside (Fig. 8).

Do not limit yourself to a tea-cup for your water. Instead, find a water bucket that holds about 1.75 litre (½ gallon) because you will need a large amount of water to keep your colours clear and bright. Otherwise your water will quickly become muddy and you will have to change it quite often. I would rather spend my time painting than looking for water.

When you are painting in the open air, it is wise to have a range of clothing and other equipment with you in case the weather changes. I recommend the following items: a strong pair of walking shoes or hiking boots; a warm, waterproof jacket or anorak; a pair of lightweight waterproof over-trousers; a suitable hat for protection from the sun or the cold; a fisherman's smock — something that I find very useful because it has front pockets which are ideal for pencils, etc., and also protects my clothes; and finally, a good sense of humour and a flask of malt whisky! I also always carry a compass with me, especially when painting in wild terrain. It is easy to lose your bearings, particularly when fog comes down and the visibility is poor, which could put you in jeopardy; a compass helps enormously in these situations.

I use an art bin to carry my paints, brushes and other materials on site. This can be purchased at most art stores and should be generously sized so that it is capable of holding all related art materials. Mine has a carrying handle and looks like a large ladies' vanity case (Fig. 9).

3 BASIC
TECHNIQUES

The old expression 'practice makes perfect' is very pertinent to painting. Although perfection is hard to achieve, practice can only improve your work. To be a great artist is a gift and not everyone will achieve greatness, but practising your technique will allow you to maximize the talents you have, and at the same time will give you much pleasure.

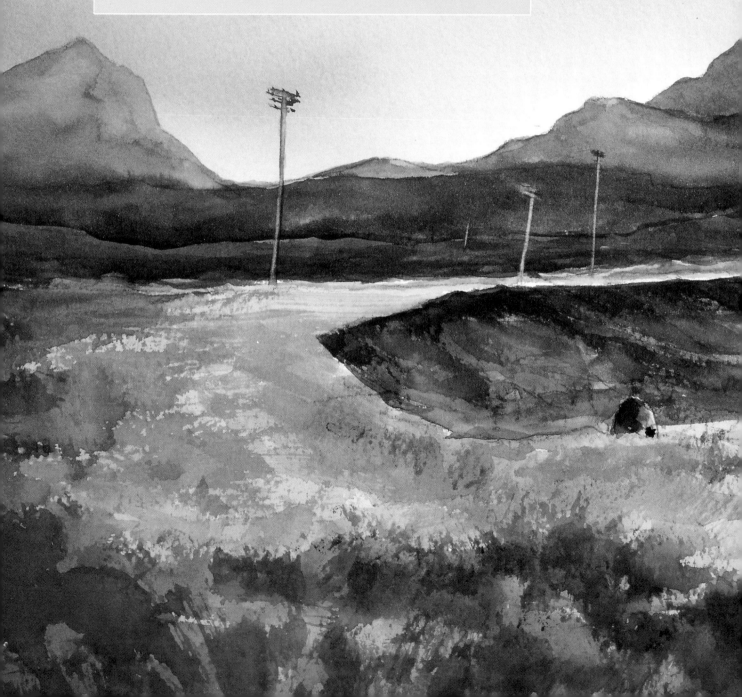

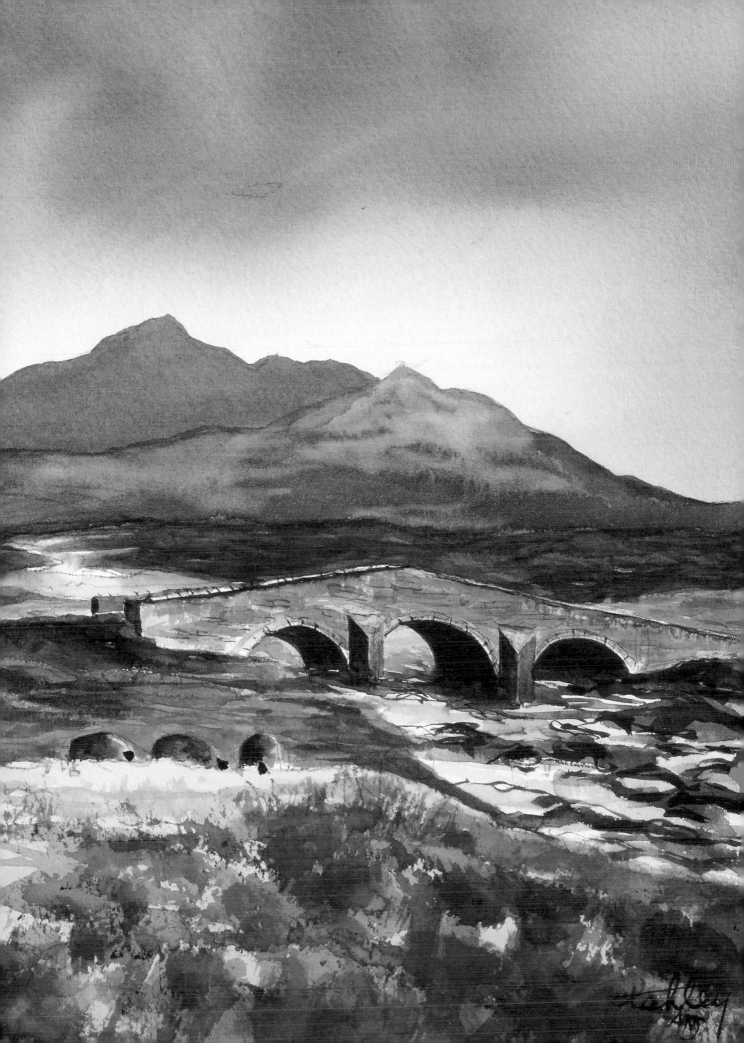

In this chapter I would like to help you in your practice by showing you a few of my techniques. Some books make watercolour techniques sound very complex, which can discourage those just starting watercolour painting. My aim in life, however, is to make painting and the teaching of painting as simple as possible – to get rid of the mumbo jumbo, as I call it.

Drawing

Drawing is very important. I use two different types of drawings in my work: simple pencil drawings which form the bases for my paintings; and ink drawings which I use for reference.

Preliminary drawings

Although some artists paint directly onto their paper without drawing first, I would not recommend this, even for an experienced artist. Creating a drawing for a painting is like building the foundations of a house: without these strong foundations, the house will fall down. In watercolour painting similarly, firm foundations are needed if the finished work is to stand up on its own.

I use a 4B pencil for drawing, the top of which is cut with a razor blade to give it a chisel edge, rather than a sharp tip which might damage the surface of the paper. The initial drawing for a painting is seen by only the artist and is used simply as a memory guide (Fig. 10a). You should therefore use the pencil very lightly, drawing only the basic outlines of the various elements in your painting and certainly no detail. Remember that watercolour is a transparent medium and if you draw in too heavily, the unsightly outlines will be visible in the finished painting. Oil painters can get away with heavier outlines because oils have a stronger covering capacity.

Another tip – something I always do – is to place arrows on your drawing to indicate the direction of light. This will help you later

PREVIOUS PAGES: *The Cuillins Are Pulling Me Away – Scotland*, Saunders Waterford 140 lb Rough, 50 × 75 cm (20 × 30 in)

Fig. 10a

Fig. 10b

when you come to consider the tonal values and have to decide where shadows should fall in the picture. Please always remember that you should paint the scene as you first saw it and with the light conditions that applied at the time. Try to freeze that first impression in your mind and learn to disregard any changes in the light or cloud formations during the time you are painting.

Sometimes, before applying any paint to my paper, I also make a tonal sketch of my subject, holding the pencil so that the side of the lead is flat on the paper (Fig. 10b). This type of drawing shows tone and depth, which is helpful when planning where shadows and contours should fall in the finished work. This subject is covered in more detail in Chapter 4. I make these drawings in any size on separate pieces of paper from my sketch pad, and refer to them as I paint.

Ink drawings

If I am particularly inspired by a scene, I often make an indelible ink drawing for my own reference; pencil ones tend to smudge and once my original painting has been sold the drawing is the only record of it that I have (Fig. 10c). As a professional artist, I have to be certain that I do not paint the same scene more than once, so this process safeguards against repetition.

Occasionally, only when the weather is very, very bad, I make an ink sketch on the spot, applying just the sky wash outdoors before returning to work on the painting in my studio. Nine times out of ten, however, a painting done in this way ends up in the bin!

Fig. 10c

BELOW: *Roxy Beck, Staithes*, Saunders Waterford 140 lb Rough, 50 × 75 cm (20 × 30 in)

33

Brush effects

It is important not only to use the right brush on the right occasion, but to practise brush control so that you will understand how each brush behaves and will discover the different effects that can be achieved.

It is also essential to learn how much paint and how much water to apply to your brush. Unfortunately, this is something that I cannot really help you with; it comes only with experience. I often judge the proportions by how heavy the brush feels in my hand, or by visualizing the eventual size of the picture. My advice is that until you are confident, do not be afraid to test out the balance in the margin of your paper. Two or three attempts there are far better than ruining your painting by applying the pigment too thickly or too thinly. Spend time working just on pigment-to-water ratios. Mastery of this technique is absolutely necessary before you come to mixing colours together, if you want to achieve confident, competent works of art.

Fig. 11 illustrates two brush strokes made with a No. 8 fill brush. This is probably the brush I use most often: apart from my washes and fine details, all other aspects of my paintings are achieved with this brush. The example on the left shows how to vary the shape of the stroke by pressing the brush down fairly hard, then lifting it up slightly. Once you have mastered this exercise, try the italic Ls, which are done in a similar way. Practise this technique until you can do it fluently.

The chisel-edged brush is the only brush in your set with a straight edge. The two exercises in Fig. 12 illustrate the subtleties of the brush that can be achieved according to the angle at which it is held: the example on the left was done by altering the angle of the brush, following the line of the stroke; the other example was done by keeping the angle of the brush constant while changing its direction, using it like an italic pen to give maximum variation between thin and thick strokes. My favourite use of this brush is for painting moorland grass tufts. I use it with very little water and make an upward, flicking stroke to create the coarse grass.

The exercise in Fig. 13 illustrates the dry-brush technique. A chisel-edged brush was loaded with colour only (no water) and was gently drawn across the paper: because the brush was so dry only some of the colour was transferred to the paper. This technique is ideal for portraying texture; you can create the illusion of bark on a tree, pebbles on a road, or reflections on the surface of water. Practise this particular technique; it will prove extremely useful to you.

In Fig. 14 I have combined the use of the two brushes previously mentioned to paint a moorland scene. The fill brush created the smooth shapes of the foliage and the chisel-edged brush created the spiky appearance of the grass and bushes. This exercise also combines wet and dry techniques: the fill

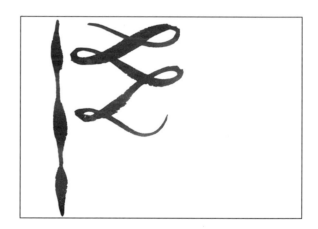

ABOVE: **Fig. 11** Varying the shape of brush strokes

BELOW: **Fig. 12** Altering the angle of brush strokes

brush was loaded with colour and water, and the chisel-edged brush with colour but no water.

Wash brushes, as their name suggests, are normally used to paint the all-important washes in your painting. However, they are also useful in other areas. In Fig. 15 I have used a wash brush almost like a stencil brush, to create grassy mounds. This was done by dabbing the colour on quickly and allowing the paint to spread on the paper like an animal's paw marks.

In Fig. 16 I have created an effect similar to the one in Fig. 14 but by using a wash brush loaded with both colour and water instead of a dry chisel-edged brush. The difference here is that I painted the grassy mounds and the tufts in one movement, filling in for the mounds and flicking out for the individual grass stems. This technique is very useful when painting a large vista of moorland.

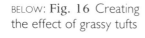

ABOVE: **Fig. 13** The dry-brush technique

BELOW: **Fig. 14** Combining wet and dry techniques

ABOVE: **Fig. 15** Dabbing on colour with a wash brush

BELOW: **Fig. 16** Creating the effect of grassy tufts

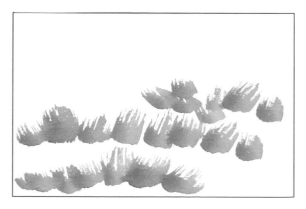

Laying a wash

Fig. 17 shows a wash painted by what I call the 'windscreen wiper' technique. I use this mainly for my skies, and the aim of the slightly curved brush strokes is to convey the feeling that the world is round. First, I wet the sky area with clean water, so that the pigment would float across the paper. Then, using smooth strokes, I moved my wash brush from left to right and right to left horizontally across the paper, like a windscreen wiper on a car, using less colour as I got nearer to the horizon. The wet paper allowed the pigment to run vertically, which resulted in light areas in the sky, giving it shape and interest.

ABOVE: **Fig. 17** Laying
a wash

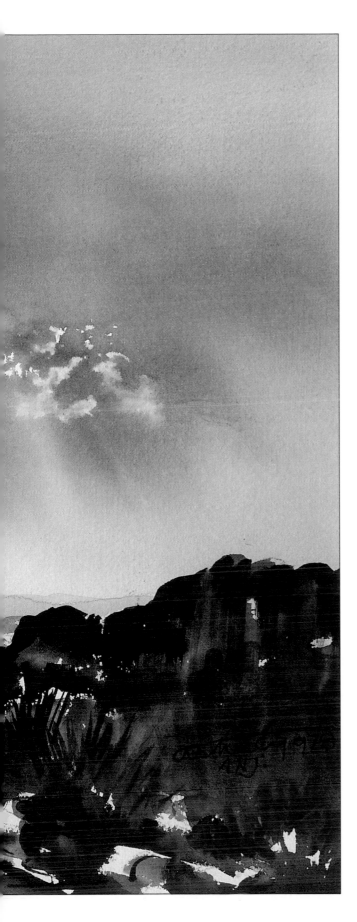

*Rain on Greenfield
Moor*, Saunders
Waterford 140 lb
Rough, 50 × 75 cm
(20 × 30 in)

Wet-into-wet technique

It is often necessary to create a soft, out-of-focus background in your painting in order to strengthen objects in the foreground and bring them into sharp relief. This can be achieved by the wet-into-wet technique (Fig. 18). First, wet the whole area with clean water and apply your sky wash, as described above. Whilst the paper is still wet, put globules of colour into the foreground, allowing the paint to spread horizontally and vertically over the area. Then, taking a dry fill brush – loaded with colour but no water – shape the foreground to give the impression of, in this case, bracken and shrubs. Once this is dry, you can put in your foreground detail on top. Incidentally, when using the wet-into-wet technique with Prussian Blue, you will find it acts like an acid on other colours, removing them rather than mixing with them.

Fishing Boats,
Cephalonia, Greece,
Saunders Waterford
140 lb Rough,
50 × 75 cm (20 × 30 in)

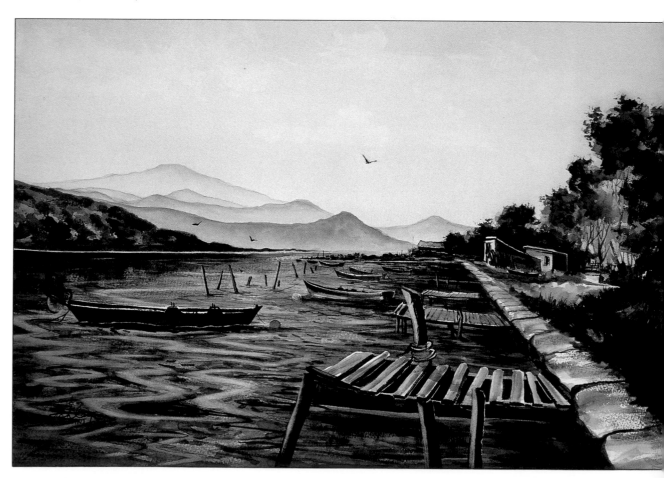

Pulling out white areas

As already mentioned, the English school of watercolour painting does not use white pigment; yet it is often necessary to show white areas in a painting. One way to do this is to leave white areas of paper in your work and in some cases I do use this technique. However, the edges of white areas produced in this way can appear rather hard and unnatural. The most natural-looking effect, particularly when painting skies, is achieved by washing in the sky colour and then pulling out white areas with your brush (Fig. 19). To do this, apply a graduated wash with your wash brush. Then rinse the brush in clean water and, taking it between your thumb and first finger, squeeze out the excess water until the brush is nearly dry. Look where the clouds appear in your sky, apply the wash brush to your painting, pressing quite heavily, then pull and twist it across the paper to form the cloud pattern you can see. The nearly dry brush will take up any colour on the paper, leaving white areas with soft edges. You can also use this technique for other features in your painting, such as the path across the moorland shown here.

White shading

In the example in Fig. 20 I wanted to show reflected light on moorland. The technique used here is very similar to the one in Fig. 19 but was done with a dry chisel-edged brush, which provided more control. Having painted in the area with a fill brush, I took a chisel-edged brush, cleaned it with water and squeezed it until it was nearly dry, then lifted out the colour in the areas where the reflections of light occurred. Because the paper was wet, the pulled out areas are soft-edged, blending well with the foliage in the painting, but they are still more clearly defined than if they had been done with a wash brush.

Fig. 18 The wet-into-wet technique

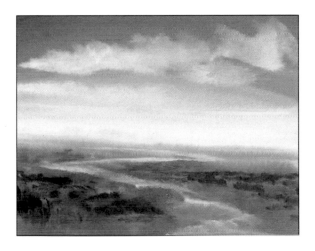

Fig. 19 Pulling out white areas

Fig. 20 White shading

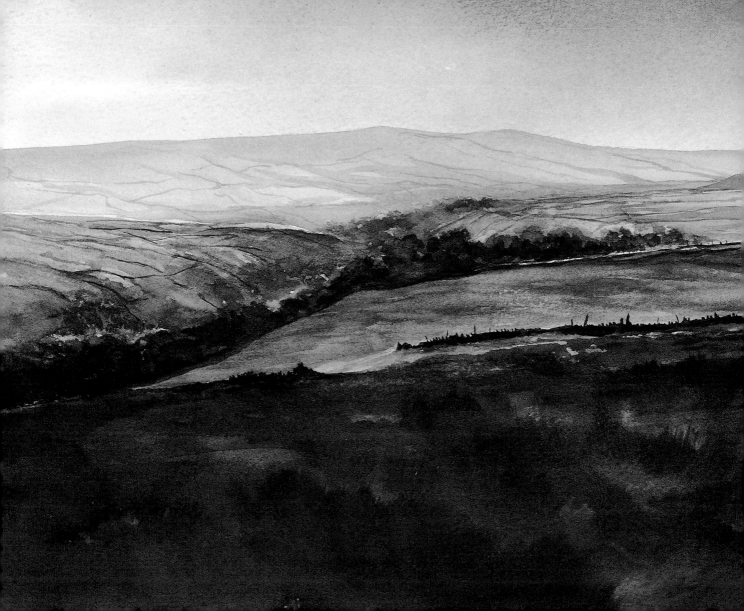

4 TONE AND COLOUR

Understanding what is meant by tonal value is far more important when painting in watercolour than in any other painting medium. Skilful use of tonal value in a painting enables you to achieve a sense of distance and depth, and helps to give objects shape and form.

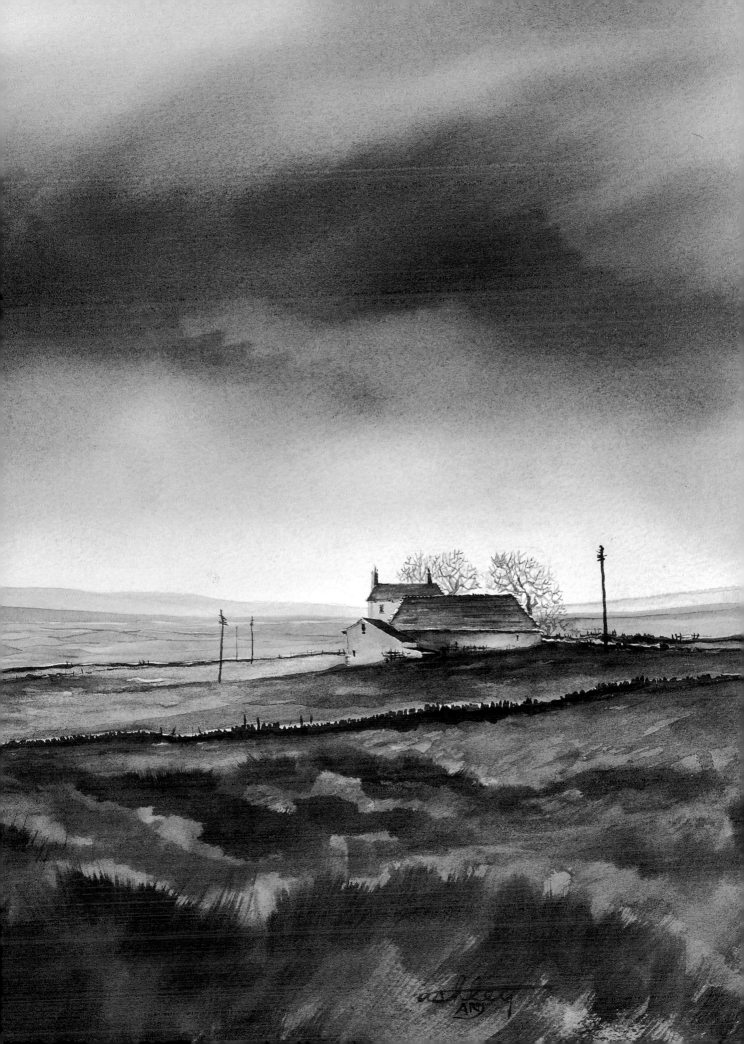

Tonal value is the degree of lightness or darkness of a colour and is controlled by adding more or less water to the mix. This is an important concept. If you look around you, you will see that forms in nature do not have black outlines defining them as in a child's colouring book: one object is distinguished from another by different tones. As a rule, foregrounds should show sharp contrasts in tone between light and dark forms. As objects become progressively more distant, the contrasts in tone should become weaker, with dark forms becoming paler and light forms less bright.

I often ask my students to view the scene that they have decided to paint with one eye closed and the other half-closed. This little optical trick affords them a tonal view of the landscape by eliminating most of the colour and emphasizing the contrasts between the light and dark areas. This allows them to see which parts of their painting will require emphasis and which will need to retreat.

PREVIOUS PAGES: *Soft Light Over Yorkshire*, Saunders Waterford 140 lb Rough, 50 × 75 cm (20 × 30 in)

Horsehouse, Yorkshire Dales, Saunders Waterford 140 lb Rough, 50 × 75 cm (20 × 30 in)

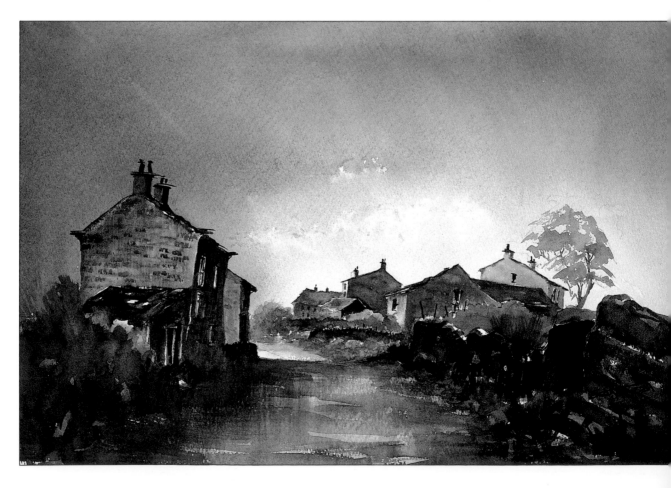

Fig. 21a

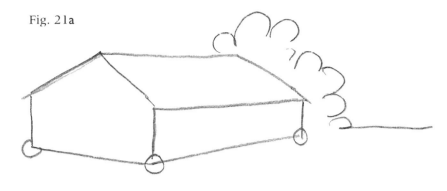

Fig. 21b

Fig. 21a shows a house as a child might draw it – a simple, flat shape. However, if you look at a house carefully you will see that in fact it does not have a hard outline as drawn here. Remember, there are no black outlines in nature. By drawing a solid line for the base, the house appears to be sitting on top of the ground, with no feeling of solidity about it. If you were to add castors to it, you could watch it roll down the hill!

To give your house depth and solidity, you must add tone. If you look at Fig. 21b you will see that there are no outlines anywhere in this illustration. The forms are created entirely by shading and tone, which give a three-dimensional feel to the drawing and convey the sense that the house has foundations below the surface of the ground and is not simply sitting on it. Always create your drawings in this manner.

Tonal values in monochromes

One of the easiest ways to learn about tone is to paint monochromes. A monochrome contains many tones of a single colour. You should always start by putting in the darker tones first, working progressively towards the lighter ones. Only once you have mastered painting monochromes should you add further colour.

I normally paint several monochromes every day, just for fun. It is a bit like practising scales on a musical instrument: the more you do, the more proficient you become. Even after all these years as an artist, when I am about to start a painting I sometimes paint a quick monochrome of my subject, just so that I can get the shapes and tones correct before I begin to work with colour.

Fig. 22 shows four small monochromes, each painted in a different colour. You can see that even when using just one colour you can achieve depth in a picture by strengthening and weakening the various tones.

Fig. 22a Prussian Blue is used here. This is a staining blue, which means that once dry it cannot be completely washed out. Because this colour contains a hint of yellow pigment in its make-up it gives the impression of coldness – a wintry feeling – to the work.

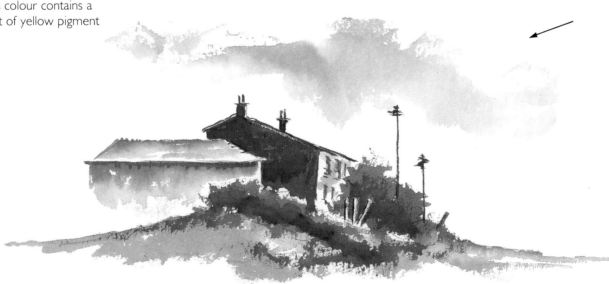

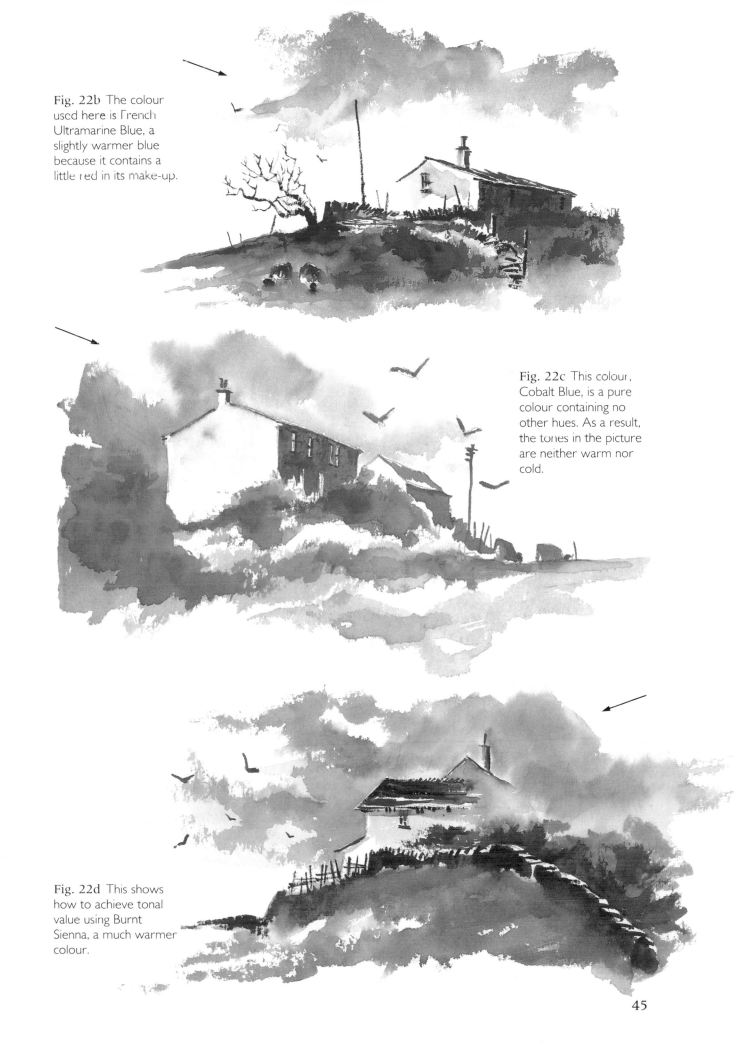

Fig. 22b The colour used here is French Ultramarine Blue, a slightly warmer blue because it contains a little red in its make-up.

Fig. 22c This colour, Cobalt Blue, is a pure colour containing no other hues. As a result, the tones in the picture are neither warm nor cold.

Fig. 22d This shows how to achieve tonal value using Burnt Sienna, a much warmer colour.

45

Creating tone with colour

Fig. 23 shows a couple of examples of how to turn a flat shape into a three-dimensional object, using tone and finally colour. Although it may be obvious to most people that the object in Fig. 23a is an apple, it looks lifeless and has no real vibrancy. By adding tone, the roundness of the apple becomes apparent (Fig. 23b), and finally, when colour is added it looks almost good enough to eat (Fig. 23c). The tree in Fig. 23d already has some colour added, yet it still looks like a flat shape. It is only when tone is applied that its form becomes defined and the tree starts to look real (Fig. 23e). Tone breathes life into objects and makes them live on the paper.

It is important to scale down the tone and colour of elements in your painting the further away they appear. You are probably quite used to scaling down the size of objects in this way. For example, if you look down a long road containing trees and houses, your eye automatically reduces their height as they recede into the distance, although your brain tells you that they are all actually the same size. Similarly, colour and tone become weaker in the distance. Unless you learn to master this technique, your painting will lack harmony.

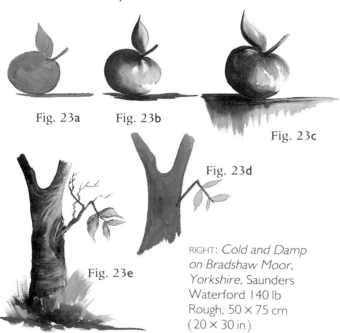

Fig. 23a Fig. 23b

Fig. 23c

Fig. 23d

Fig. 23e

RIGHT: *Cold and Damp on Bradshaw Moor, Yorkshire*, Saunders Waterford 140 lb Rough, 50 × 75 cm (20 × 30 in)

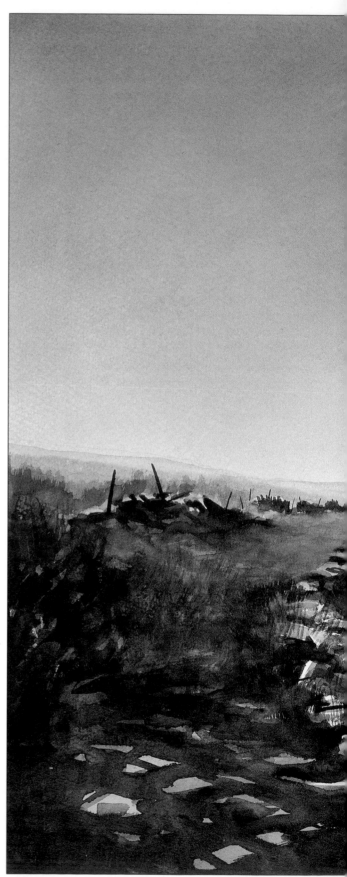

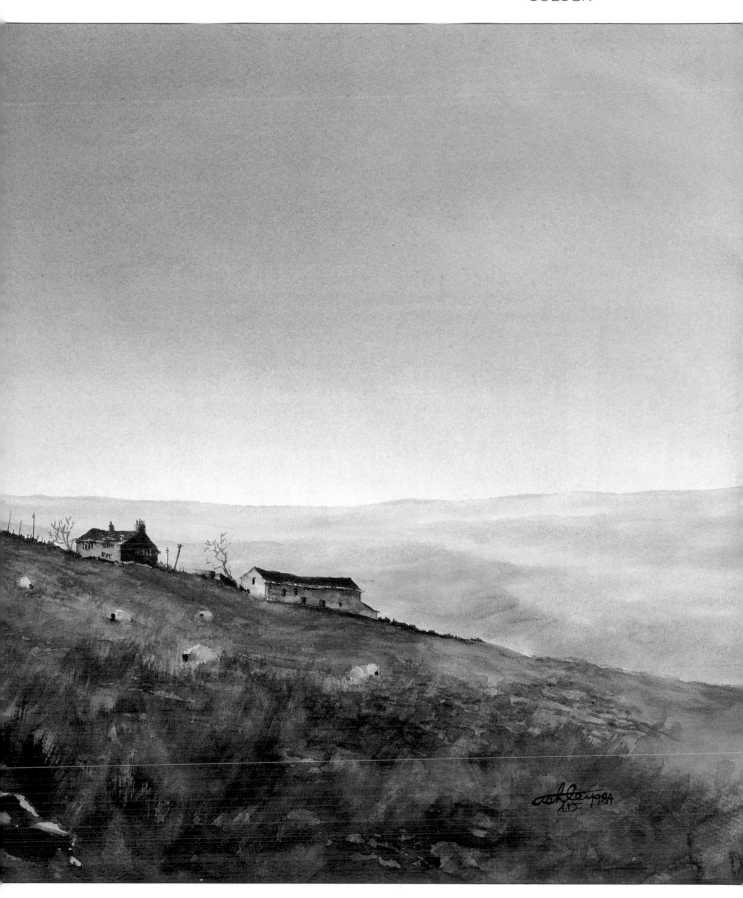

Fig. 24a This shows
the basic, flat painting
without any tonal value.

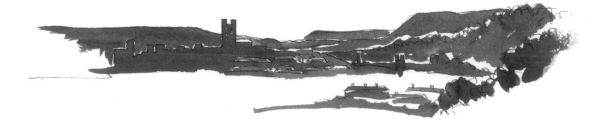

Fig. 24b This stage is
similar to the previous
one, but with tone
added in the same
colour to give emphasis
to the light and dark
areas of the painting.

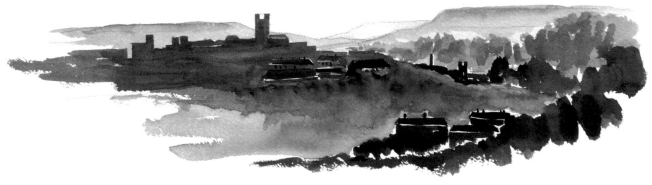

Fig. 24c The first
colour to be added is
Crimson Alizarin, with
strong tones in the
foreground, weaker
tones in the distance.
This already gives the
painting a warmer feel
and more depth. The
colour is applied to the
areas that will most
obviously lead your eye
into the work.

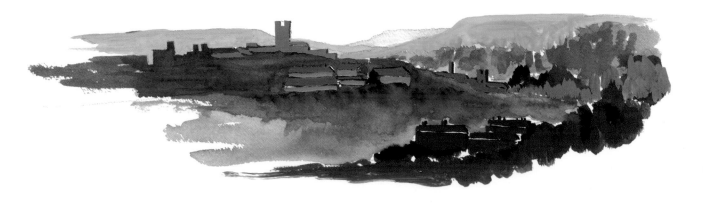

In the exercise in Fig. 24 the painting is built up in a number of stages. First tone is added and then several washes of watercolour are laid on, one on top of the other. I think of these washes as being rather like coloured sheets of glass, especially since watercolour is a transparent medium.

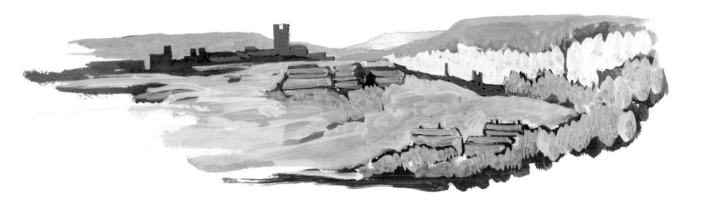

ABOVE: **Fig. 24d**
A strong tone of Cadmium Yellow is added next to the foreground, with a weaker wash of the same colour applied in the distance. This has the effect of warming up the middle distance and giving the picture a three-dimensional feel.

BELOW: **Fig. 24e** Finally, French Ultramarine Blue is added to the middle distance, the trees on the right, and the church and buildings in the distance. By adding the blue, the green tints in the forest and grassy areas are achieved. The distant hills are pushed back by

the use of a weaker tone and the middle-distance feature – the church – is given prominence by the use of a darker tone so that it is now coldly silhouetted against the pale hills.

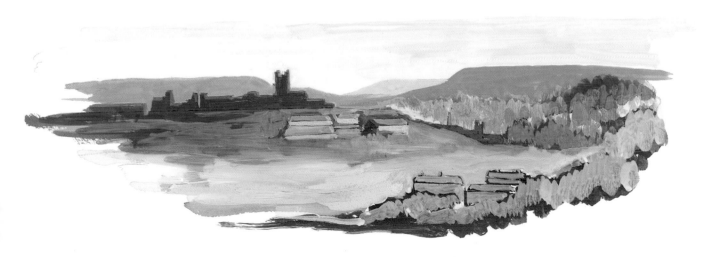

The family of colours

The mixing and quality of colour on your palette, together with a knowledge of which colours blend naturally with others, is very important. Like all the other techniques, when it comes to colour mixing practice is the only way to try to achieve perfection. Learning how to obtain the different tints and hues will give you a true understanding of the colours in nature, and will help you to portray them on your paper.

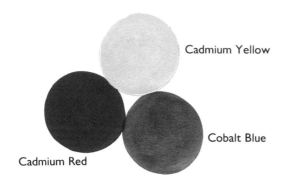

Fig. 25a This illustrates the three primary colours.

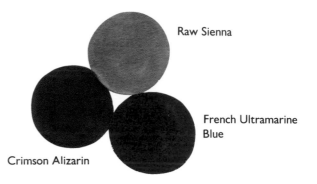

Fig. 25c These are entitled to be called basic colours, but none of them is a primary colour because each contains a tint of another colour. Crimson Alizarin has a hint of blue in it; French Ultramarine Blue and Raw Sienna contain a hint of red.

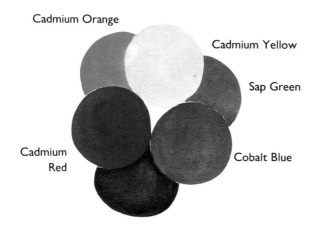

Fig. 25b Here the primary colours are shown with the secondary colours that are made when each pair is mixed together. Most people think that mixing a primary red with a primary blue will give you purple; but what you get, in fact, as you can see, is a muddy mauve colour.

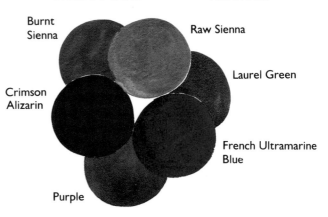

Fig. 25d Here you can see that you need to mix Crimson Alizarin and French Ultramarine Blue to make purple.

Generally speaking, the warmer colours, such as reds and yellows, create a more vibrant and stimulating atmosphere in a painting, whereas the cooler blues, greys and greens make for a more relaxed and peaceful mood. Cool colours suggest a sense of space, whilst warm colours can be claustrophobic. That is not to say you should never be excited by warm colour in a landscape, but try to harmonize it to give the viewer a feeling of serenity.

In painting there are only three primary colours: Cadmium Red, Cadmium Yellow and Cobalt Blue. You should really use Vermilion as your primary red, but it is so expensive these days that I generally substitute Cadmium Red, which I find equally good.

Apart from Cadmium Red, Cadmium Yellow and Cobalt Blue, which are pure colours, all colours contain secondary colours within their make-up. A true artist will always be aware of the secondary content of a colour and will use this knowledge to advantage. Some basic colour mixes are illustrated in Fig. 25.

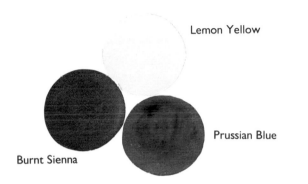

Lemon Yellow

Prussian Blue

Burnt Sienna

Fig. 25e Three more basic colours are shown here. I always tell my students to think of Burnt Sienna as a red, rather than a brown, as it mixes far more easily in the family of reds.

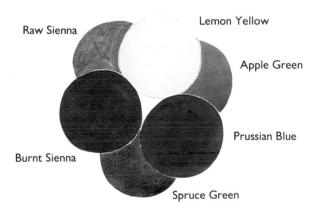

Raw Sienna

Lemon Yellow

Apple Green

Prussian Blue

Burnt Sienna

Spruce Green

Fig. 25f You may be surprised to see here that not only do blue and yellow make green, but Burnt Sienna and Prussian Blue also do!

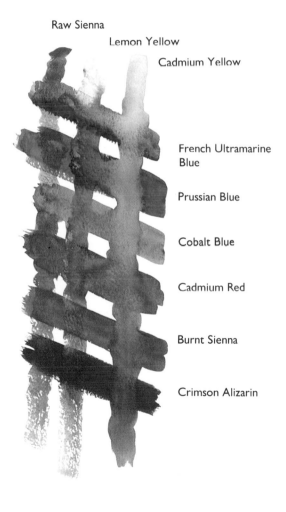

Raw Sienna

Lemon Yellow

Cadmium Yellow

French Ultramarine Blue

Prussian Blue

Cobalt Blue

Cadmium Red

Burnt Sienna

Crimson Alizarin

Fig. 25g This illustration contains my family of colours – three reds, three yellows and three blues, together with the colours they form when mixed together. You will be able to mix virtually all the colours you will need in your everyday painting from these basic colours.

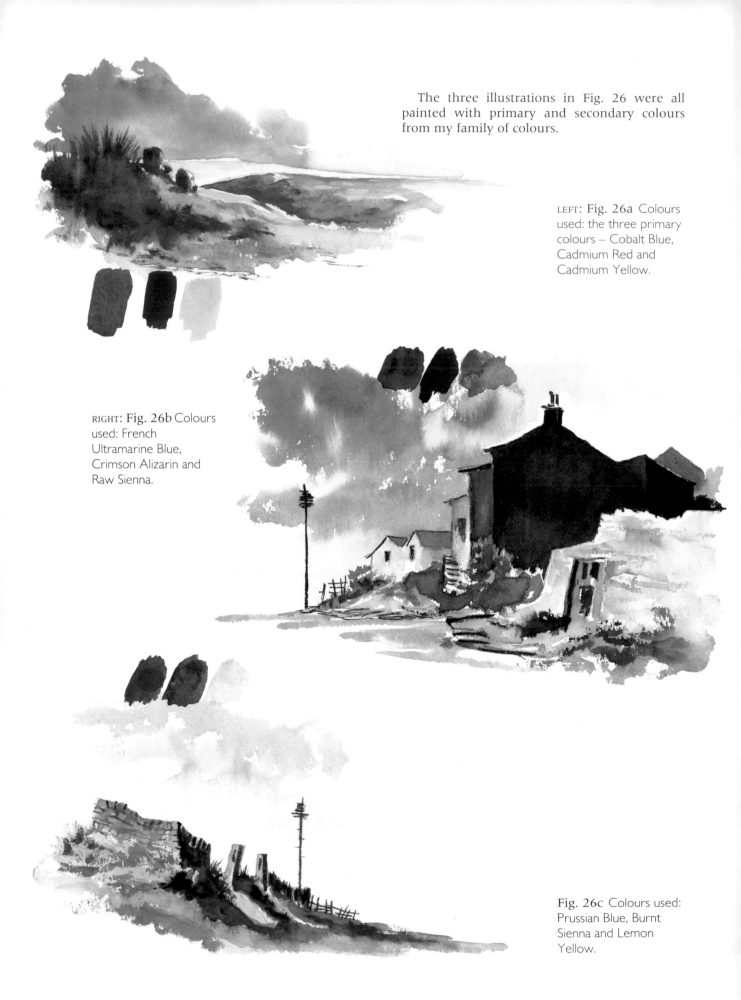

The three illustrations in Fig. 26 were all painted with primary and secondary colours from my family of colours.

LEFT: **Fig. 26a** Colours used: the three primary colours – Cobalt Blue, Cadmium Red and Cadmium Yellow.

RIGHT: **Fig. 26b** Colours used: French Ultramarine Blue, Crimson Alizarin and Raw Sienna.

Fig. 26c Colours used: Prussian Blue, Burnt Sienna and Lemon Yellow.

Glen Coe, Scotland
In this painting I tried to capture the
majesty of the mountains and the feeling
of space. As I worked I was very aware of
the history of the place and the terrible
massacre that occurred there, and I tried to
interpret the mood of the glen by using
strong tones and colours. This is the beauty
of painting outdoors.

Glen Coe, Scotland,
Saunders Waterford
140 lb Rough,
50 × 75 cm (20 × 30 in)

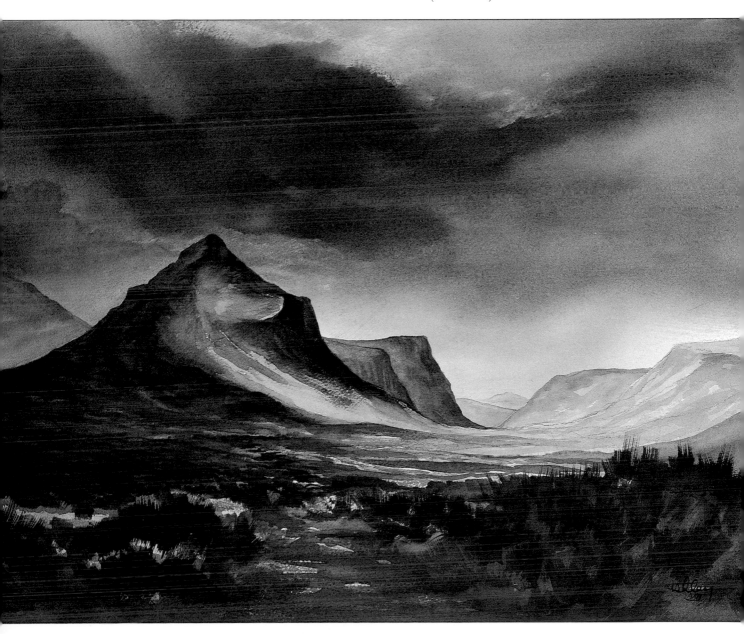

Changing light conditions

Colours change according to the available light. The three exercises in Fig. 27 illustrate how different light effects can therefore be portrayed through the use of appropriate colours. Each exercise shows the same scene painted on the same day, but at different times – in the morning, at midday and in the afternoon. The effect that moving light has on the landscape can be seen clearly.

The first picture was painted at 8.45 a.m. (Fig. 27a). I was on top of Bradshaw Moor in Yorkshire, looking down on two farmhouses. At this time of day the light was coming from the left as I looked at my subject, so I placed arrows in the illustration to show its direction. The sun was not quite up, so there was a lovely soft light. The colours I used for this morning scene are Prussian Blue, Lemon Yellow, Burnt Sienna and Raw Sienna. Because it was a cold morning I used Prussian Blue as my key colour. A key colour is one that is taken from

the sky and is mixed, in small quantities, into all the other colours in a painting – like putting a pinch of salt in food. So I used a touch of that key colour, Prussian Blue, for my walls, grass, trees and fells. The colours of the painting harmonize as a result of bringing this hint of colour into everything.

Fig. 27b shows the same scene, but at midday. The sun had moved dramatically when I painted this: it came in from the left in the early morning, but now it was coming from the right. For this version of the picture, I used Cobalt Blue together with Prussian Blue, Burnt Sienna and Lemon Yellow because the scene was now warmer. Mixing the two blues together gave me my key colour. Again, whatever colour I mixed, I made sure that I used equal quantities of Cobalt Blue and Prussian Blue in the mix. You will see that the shadow areas are different from those in the earlier painting; the direction of light has changed and reshaped the whole scene. You will also notice that I added more Lemon Yellow as the day was now brighter.

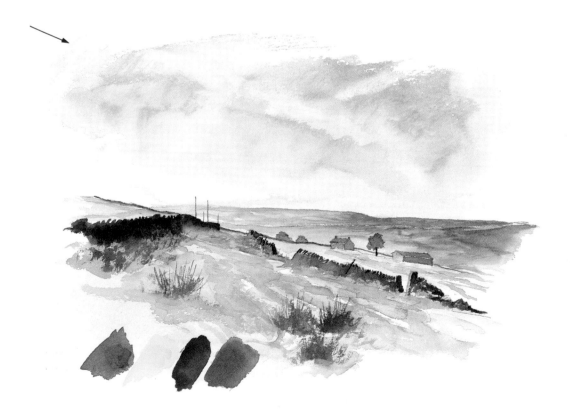

Fig. 27a

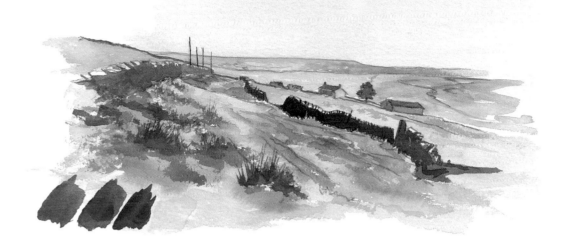

Fig. 27b

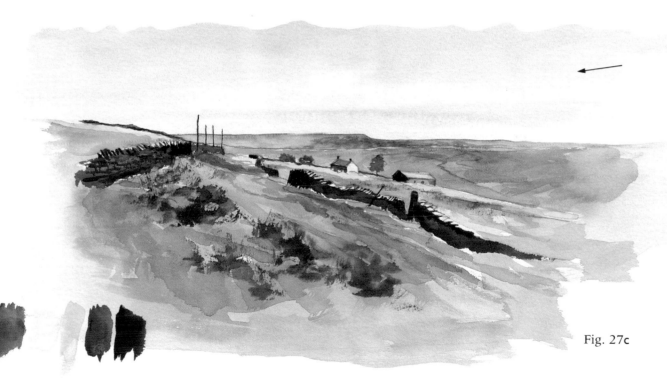

Fig. 27c

The painting in Fig. 27c was started at 5 p.m. You will see that the arrows indicating the direction of light are still coming in from the right-hand side, but they have dropped down a little and are almost horizontal. The colours in the picture – Prussian Blue, Lemon Yellow, Cadmium Yellow, Burnt Sienna and Crimson Alizarin – have warmed up as the day turned to evening. The key colour is still Prussian Blue, but tonally weaker than it was before. On this occasion the sky is mainly blue, with no yellow in it, but far in the distance there is a hint of crimson. Usually, cool blues are used in the distance, to suggest recession, but here I added a little Crimson Alizarin because this is a cool red and it gives an extra sense of coldness to the evening sky. I will talk more about this use of colour in Chapter 5.

Seasonal colours

Here is an exercise showing spring and winter pictures of the same subject, the village of Horsehouse in the Yorkshire Dales (Fig. 28). The effect of the different seasons is achieved by the use of colour – fresh colours, such as yellow, to suggest spring and cool blues to give a chilly feel to a winter scene.

Very occasionally, I change the season in my paintings for reasons of necessity. Perhaps someone has asked me in the summer to paint a particular scene as though it were winter; or maybe I suddenly get the urge to paint in spring colours a scene I have already painted in the autumn but cannot find time to revisit. Then I get out my 'cheat' set. This is

a series of cardboard window mounts covered in coloured cellophane, rather like the coloured filters used over the lights in a theatre. If the scene I want to paint is cold and wintry, just by viewing it through yellow, light brown or red filters, I can see how it would look in warmer conditions. Conversely, the use of a blue filter in summer gives me a good idea how the scene might look in winter. These colour mounts are no substitute for the real thing, but they will certainly be an aid to your work when situations dictate.

For the spring painting in Fig. 28a I used Prussian Blue, French Ultramarine Blue, Lemon Yellow, Burnt Sienna and Crimson Alizarin. You will see that there is some yellow in the sky, but to ensure that this

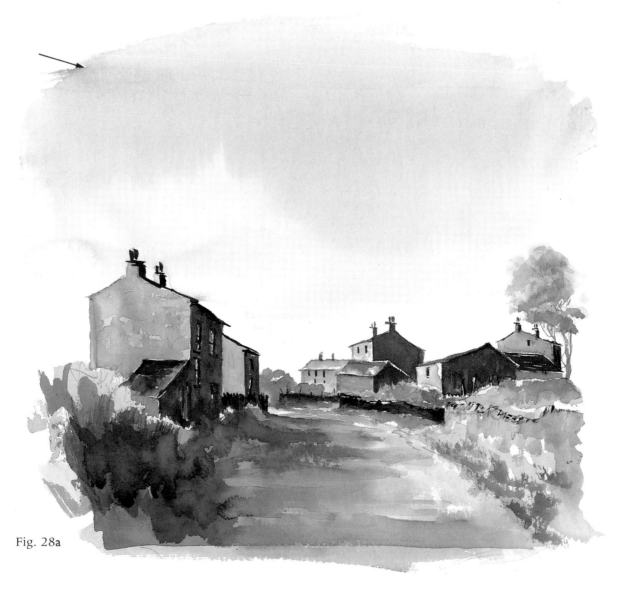

Fig. 28a

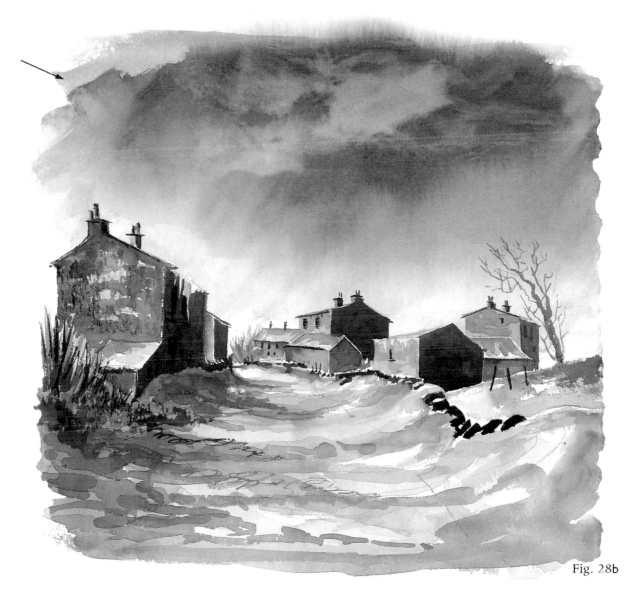

yellow did not end up too green, I mixed a little Burnt Sienna in with it. I dampened the sky area first with clean water and then mixed the two blues to form my key colour, using equal quantities of both. I applied this as a wash and left the sky to dry, concentrating on all the other areas of the painting that required blue. I then used a hint of Crimson Alizarin and Burnt Sienna to tone down the yellows slightly. Next, I put in all the weak tones – the yellows, greys and reds – and then built upon them. In this painting I tried to achieve a feeling that spring is in the air, and using yellow contributes to that effect.

Fig. 28b shows the scene in winter clothing. The same colours were used as for the spring painting, but in stronger tones. First, I mixed the two blues together, then rinsed my brush and applied a fair amount of clean water to the sky area. Before this could dry, I washed in the blue, using the wet-into-wet technique, and finally added a pin-head of Burnt Sienna and Crimson Alizarin directly on the paper, rather than mixing it first on the palette, to give a dramatic quality to the winter sky. When the paper was semi-dry, I took my squirrel hair brush, moistened it with clean water and pulled out the cloud formations, as described in Chapter 3. I used blue to emphasize the shadows on the snow, which contrasted against the whiteness of the paper. I achieved the grey areas by mixing the two blues with a pin-head of Crimson Alizarin and Burnt Sienna, then finally, again using the two blues as my key colour, I added Lemon Yellow and Burnt Sienna to it and put in the houses, varying the tone according to the reflected light.

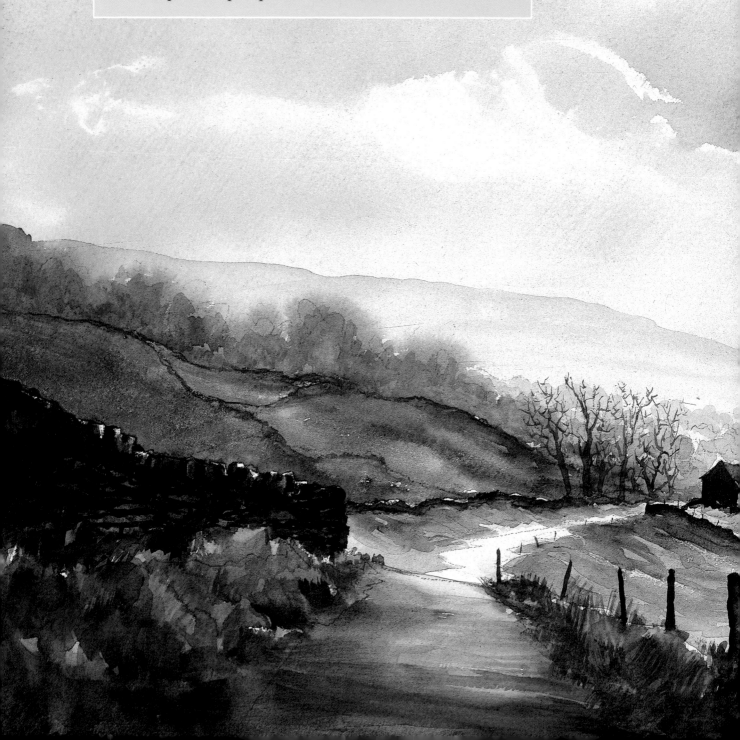

5 PERSPECTIVE IN COLOUR

Many artists use the term 'aerial perspective' to refer to the changing tones and colours which create a sense of space in a painting, yet I find this misleading and inaccurate. I would much rather use the phrase 'perspective in colour'.

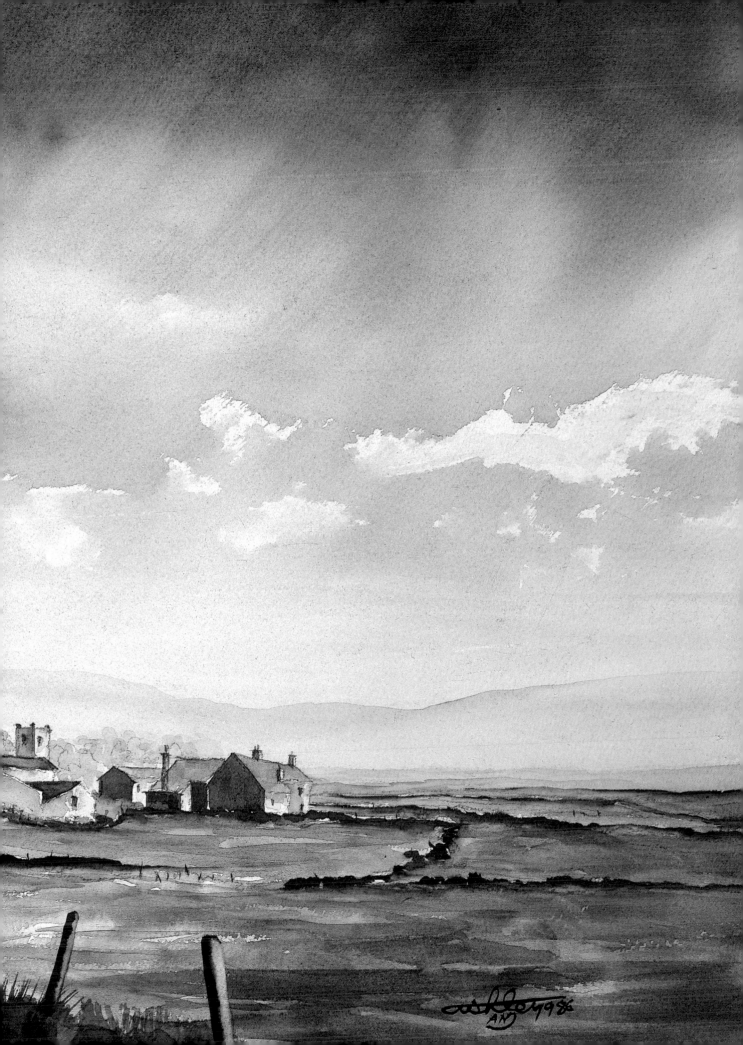

PREVIOUS PAGES: *Moving Light, Merrick Priory, Swaledale*, Saunders Waterford 140 lb Rough, 50 × 75 cm (20 × 30 in) (By kind permission of The Prince's Youth Business Trust)

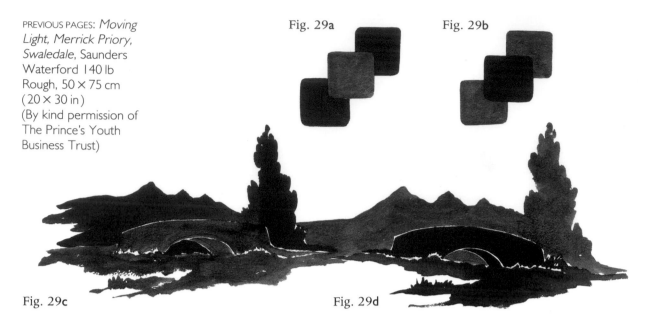

Fig. 29a Fig. 29b

Fig. 29c

Fig. 29d

When you view a finished painting, particularly a landscape, you should be able to feel that you could walk into the painting and experience the breadth and depth of the panorama. This illusion is achieved by the appropriate use of warm and cold colours within the painting. Calling this 'aerial perspective' can confuse the novice, who might assume that in order to get right into the subject he would need to paint from the cockpit of an aeroplane! So dismiss the concept of 'aerial perspective' and concentrate your thoughts on 'perspective in colour'.

To show how this works in practice, I have devised an exercise using just two primary colours – red and blue (Fig. 29). You will notice that in Fig. 29a, in which the blue square is in front of the two red squares, there is no suggestion of any space between the blue and the red: all the squares appear to be on the same plane. The reason for this is that red is an advancing colour whereas blue is a retreating one. So although the red is in the background, it appears to move forwards, pushing away the blue, which in turn recedes.

In Fig. 29b, however, you will see that I have transposed the colours, placing the red square on top of the two blue ones. This suggests quite clearly that there is space between the squares, thereby creating perspective in colour.

Study this exercise carefully. If you cannot see the difference between the two examples, then may I politely suggest that you take up gardening or some other leisure pursuit, as this is a fundamental concept which all would-be painters need to understand: without doing so you will not be able to paint either abstract or figurative pictures.

In Fig. 29c I have painted a simple view of a bridge in the foreground with mountains in the background. However, because the bridge is painted in blue, a retreating colour, and the mountains in red, an advancing colour, your eye automatically zeroes in on the mountains first. This has the effect of making them the most important feature of the painting, rather than the bridge in the foreground which is really the focal point of the work. By transposing the colours (Fig. 29d), the bridge instantly becomes the focal point, whilst the mountains fade into the background. The illusion of space in this painting adds a dimension impossible to achieve in Fig. 29c.

Once you have seen colour perspective in simple terms and understand its basic rules, you can develop them in order to create more depth and atmosphere in your paintings, as illustrated in Fig. 30. For these simple paintings of a farmhouse and barn I used three colours – French Ultramarine Blue, Crimson Alizarin and Cadmium Red.

ABOVE: **Fig. 30a** Here the colour perspective is wrong: the gable end is a cold blue and therefore recedes, making a hole in the picture; the barn is painted in a colour which is neither cold nor warm; and the tree is a fiery red. As a result, it is the tree your eye sees first, although this is supposed to be in the background. In fact, all three elements come together on one flat plane which does not allow for any colour perspective within the painting.

BELOW: **Fig. 30b** In this example the colour perspective has been corrected. The gable end is now a fiery red and therefore advances towards you. The barn is crimson, a cool red, so it recedes behind the gable end, and the tree, now a cold blue, forms the background of the picture, retreating behind the other, more major elements and creating a sense of even greater depth.

BELOW: **Fig. 30c** Here all three colours have been mixed. This example shows how a combination of tone and colour perspective, together with additional detail, can be successfully used to achieve a harmonious picture which has much greater shape, depth and atmosphere.

Mount Jefferson from Lake Detroit, Oregon, USA

I painted this landscape on my travels in the USA in the picturesque state of Oregon. Lake Detroit is a beautiful lake, high in the mountains near the tourist resort of Bend, famous for its Indian reservation and annual rodeo. The painting contains many of the elements I have described in relation to colour perspective. For instance, the immediate foreground is in shadow, hence the cool, dark tones used. The trees in the mid-foreground on the right are spotlit by the rays of the sun and are therefore warm in tone and colour. In contrast, the trees in the left mid-foreground are painted in cold colours as they are in shadow and silhouetted. As your eye travels into the painting via the lake, you will notice that the colours get progressively cooler and the tones weaker, giving depth and recession to the scene. The weakest and coolest element tonally in the whole painting is the mountain, which looks as if it is a long way away from the lakeside. Had I used strong tones and warm colours for the mountain, it would have appeared much closer, and the painting would thereby have lost the panoramic effect that I wished to create.

Mount Jefferson from Lake Detroit, Oregon, USA, Saunders Waterford 140 lb Rough, 50 × 75 cm (20 × 30 in)

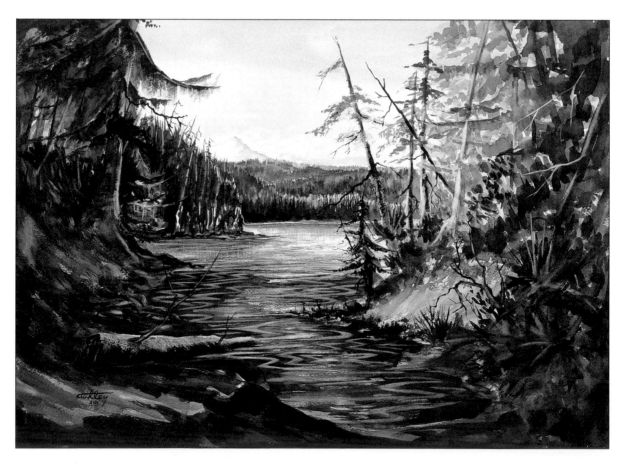

Bradshaw Moor

The sky in landscape painting is nearly always the most important element and therefore should be treated with the utmost care. As a general rule, paintings of hilly or mountainous areas should contain one third sky and two thirds landscape. The reverse applies to paintings of flat landscapes. In this particular painting the sky is dominant.

Colours and paper used: Crimson Alizarin, French Ultramarine Blue, Prussian Blue, Lemon Yellow, Burnt Sienna and Raw Sienna; Saunders Waterford 140 lb Rough.

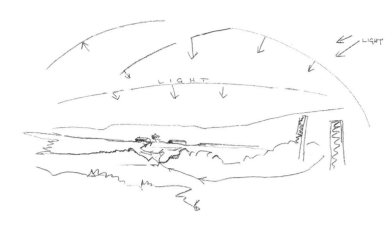

ABOVE: **Fig. 31**
Preliminary drawing

Fig. 32 Stage One

Drawing

I lightly drew in the basic outlines of the various elements of the painting and added arrows to indicate the direction of light. I also put in arrows to show how the viewer's eye would be drawn into the painting towards the farmhouse in the middle distance.

Stage One

With my wash brush I damped the sky area so that the wash would float across the paper evenly. This is the technique, you will remember, which enables you to form clouds by pulling out areas of colour. Then I mixed French Ultramarine Blue with Prussian Blue, together with a touch of Crimson

Alizarin, and applied this as a wash, the strongest tones at the top of the painting becoming weaker as they neared the distant hills. I dropped in a Raw Sienna wash just above these hills to warm up the sky a little. I prefer to use Raw Sienna instead of Yellow Ochre in this case because the secondary colour in the former is red, which stops the blues turning green when using the wet-into-wet technique; Yellow Ochre would turn the sky green. Next, using my natural hair wash brush, I pulled out areas of colour to form the clouds.

Fig. 33 Stage Two

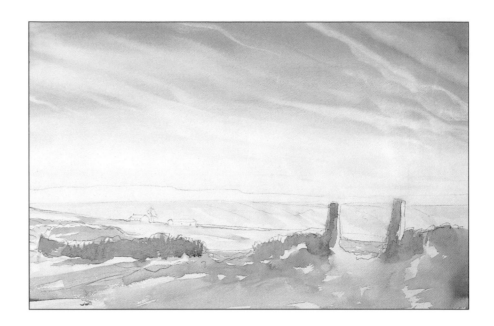

Stage Two

Using the same colours as for the sky, but tonally weaker, I then painted in the distant hills. Moving to the foreground, I used a similar mix of French Ultramarine Blue, Prussian Blue and Crimson Alizarin, but without Raw Sienna, to put in the wall, gateposts and all the shaded areas of the painting. Common sense will tell you that you have to wait for each wash to dry here before applying the next one, otherwise they will bleed into one another, losing definition. After allowing a suitable drying time, I then concentrated on the grassy areas of the painting, using a colour mix of Prussian Blue, Lemon Yellow and a touch of French Ultramarine Blue. You will see that the tones get stronger towards the foreground, thereby creating a feeling of depth.

Stage Three

Once the colour washes over the distant hills had dried, I applied further washes of the same colours, but tonally stronger, to give added shape to the hills. With my fill brush I then used French Ultramarine Blue, Prussian Blue and Crimson Alizarin to put in some detail on the walls and the gateposts. I also worked further on the foreground, using the same colours as before, but tonally stronger, and added some grassy tufts.

Final Stage

Using a stronger mix of the sky colour, I darkened the walls further, continuing to work on individual stones. I painted in the farmhouse and the tree and telegraph poles nearby, then added more detail to the whole of the foreground and middle distance. Lastly, to complete the painting, I sharpened the detail of the gateposts and put in the fence supports, positioning them so that they lead the observer into the picture.

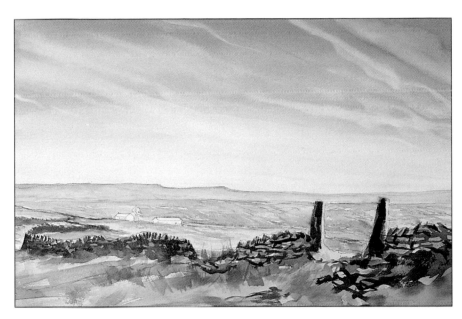

Fig. 34 Stage Three

BELOW: **Fig. 35** Final
Stage: *Bradshaw Moor*,
50 × 75 cm (20 × 30 in)

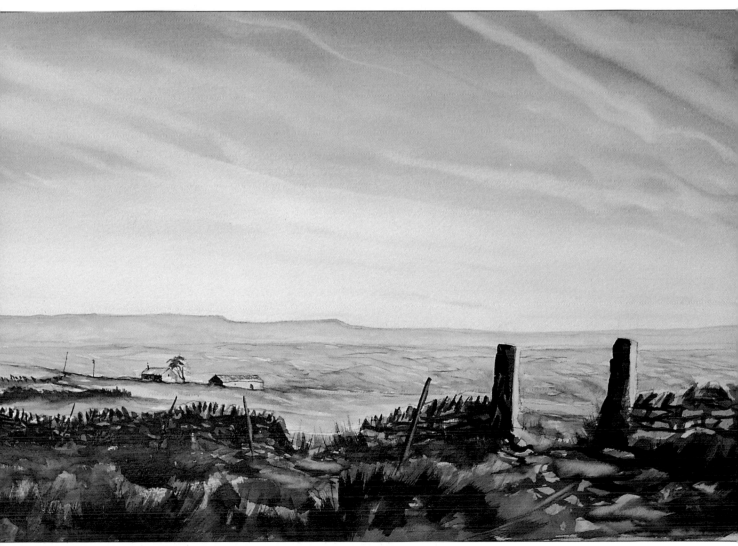

6 METHODS OF COMPOSITION

Good composition is much more than just a strict arrangement of the shapes you can see in a landscape. You should never be afraid to move the odd wall or tree around in order to make your painting more interesting or dramatic. Leave layout to the photographer; composition is for the artist.

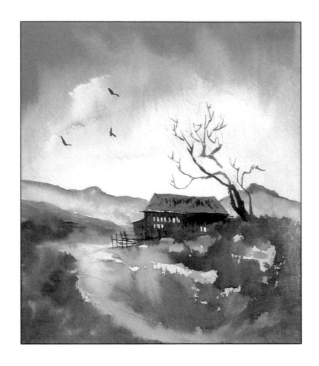

Fig. 36a

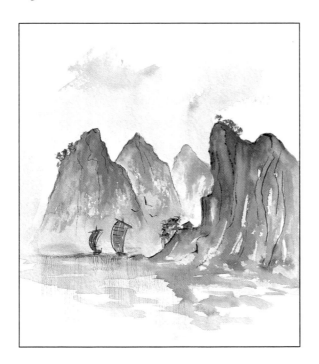

Fig. 36b

PREVIOUS PAGES: *Winter Solitude*, Saunders Waterford 140 lb Rough, 50 × 75 cm (20 × 30 in)

Music and art have many similarities. A composer first hears his new-born musical work in his head but by the use of musical notation he is able to translate it onto paper. Another musician can then come along and play the composer's work note for note or he may choose to extemporize or embellish the work slightly, remaining essentially true to the original but putting a little of his own personality into it. The same situation applies to the artist. He has the ability to hold an image of a particular scene in his head and then transcribe it onto paper by drawing and painting. He can also use artistic licence to change one or two features of the original view to make it more harmonious as a painting.

There are two different schools of thought on the subject of composition. Fig. 36a illustrates an example of the classic European approach to composition used by the Old Masters, such as Da Vinci and Rembrandt, featuring four dark corners which slowly draw the eye towards the focal point of interest. Fig. 36b shows the classic Chinese style of composition, which concentrates immediately on the focal point and then draws the eye out from the centre to the four light corners. J.M.W. Turner was before his time in using the Chinese approach to composition in some of his paintings, namely *Rain, Steam and Speed* and *The Fighting Temeraire*. In these the foreground appears blurred and the eye is therefore drawn straight in to the subject.

Letter-shape compositions

Most art instruction books refer to the Golden Mean when discussing composition. I find this rather complicated and use a much simpler and more direct way of explaining the best methods by which an artist composes his work. I think of composition in terms of the shapes of certain letters of the alphabet: some letters, such as L and Z, provide the bases for good compositions; others, such as X and U, are best avoided. This is illustrated in the following six examples.

Fig. 37a Avoid placing the focal point of your composition in the centre of the paper. This results in an X composition, which is rather uninteresting.

Fig. 37b It is just as bad, however, to have nothing in the centre of your work. Such a composition, also X-shaped, results in an unsatisfying picture.

Fig. 37c Like the X composition, the U composition should, in my opinion, be avoided. It is, in fact, two paintings split by a void.

Fig. 37d The L-shaped composition is many painters' favourite. It places the focal point off-centre, and gives balance and depth to the foreground.

Fig. 37e This is an interesting exercise because although at first glance it looks like a U composition, it is actually made up of two overlapping L shapes. By placing warmer tones on one side of a painting and colder tones on the other, the problematic U can be avoided.

Fig. 37f The Z composition is perhaps the most difficult to achieve but is very effective in the way it leads the eye through the painting.

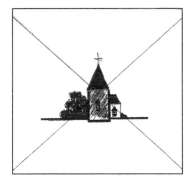

Fig. 37a

Fig. 37b

Fig. 37c

Fig. 37d

Fig. 37e

Fig. 37f

I find it helpful to use two L-shaped pieces of mounting card when looking for a suitable composition. Each measures 25 cm (10 in) along the 'leg', 20 cm (8 in) along the 'foot', and is 5 cm (2 in) wide. You can take these out into the countryside and hold them up to establish whether a composition is L-shaped or double L-shaped. For example, if there is a tree with some buildings at the side of it on the left-hand side of your proposed composition and a flatter area of fields and bushes on the right-hand side, you have an L-shaped composition which would make an interesting painting. The trunk of the tree and the buildings form the 'leg' of the L and the ground you are viewing them from is the 'foot' of the L.

Choosing your viewpoint

Fig. 38 includes two paintings of the same subject, seen from different viewpoints. Fig. 38a is an example of how *not* to compose a picture. Although the subject is a good one, the angle chosen here is so awkward that the finished painting looks boring and totally uninspiring. When an artist is commissioned to paint a well-known building, or even a friend's house, it is vital that he chooses a good angle from which to paint it, otherwise the outcome is likely to be disappointing, however technically correct it may be. Whenever you paint a subject such as this, spend time looking at all the possible

Fig. 38a

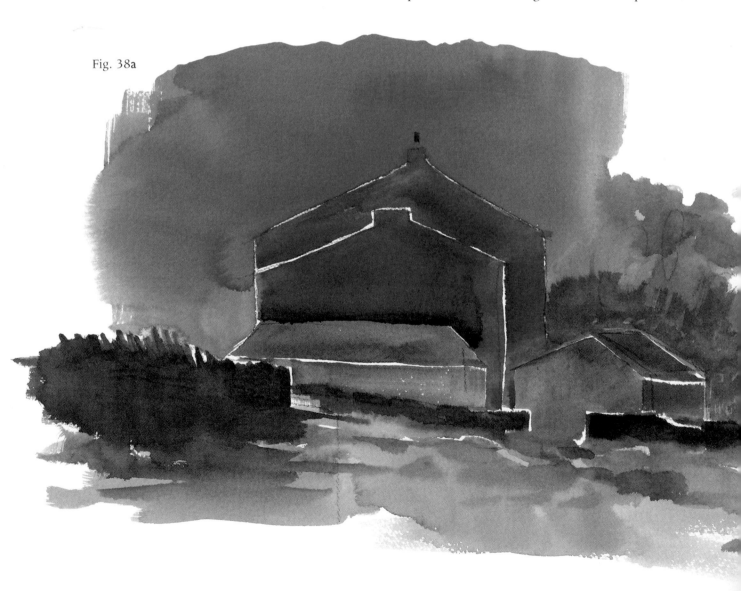

vantage points before you decide which one most pleases the eye. The end result will be well worth the time and trouble. It is far better to look for an hour and then paint for ten minutes than vice versa. See how much more interesting the composition in Fig. 38b is.

When you have nearly finished a painting you will find it useful to place a mount or mat around it. This frames the painting and helps to pull the composition together so that you can see what it will look like when completely finished. This is the time to decide what final corrections or additions are needed. Always show people your finished paintings with mounts around them as these will enhance your work.

Fig. 38b

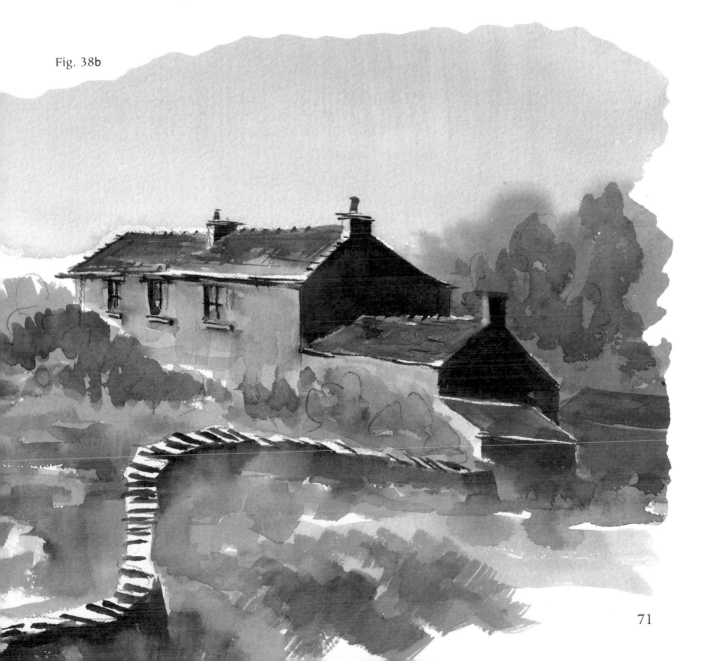

The camera versus the eye

I know many artists prefer to take photographs of their subjects in order to re-create the scene later in their studio and as an aid to composition. Personally, I don't. I like to work direct from nature in the open air, to capture the atmosphere of the landscape there and then on paper. It is a personal thing, but it works for me. A good photographer with an expensive camera may be able to see good compositions through the viewfinder, but someone taking snaps with cheap equipment will find it very difficult to re-create an original scene from a photograph later on. Before the camera was invented, artists had to create pictures by using their eyes and I believe this is still the best way.

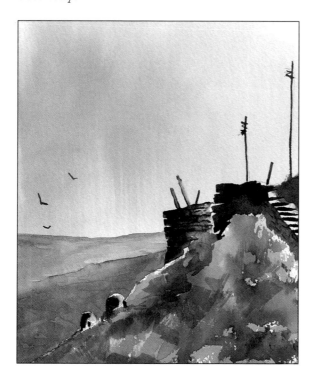

Fig. 39

Focal points and escape points

Particularly when painting landscapes you should always give the observer the impression that life continues beyond the horizon. 'Escape points' are necessary to the success of the finished work. Many people get claustrophobic when viewing paintings that do not have an escape point. They probably do not know why the painting makes them uneasy; they just feel that something is missing. Many classic portraits by the Old Masters contain small windows or apertures allowing the observer a point of escape from the painting.

When you first plan your picture, always be conscious of providing a route within your work that will lead the viewer's eye to where you want it to go. A good artist controls not only the painting but also the way in which it is finally observed.

Study Fig. 39 carefully. Your eye should immediately be drawn to the meeting of the two walls, then be re-routed to the sheep in the foreground, before finally escaping via the light area on the hills in the distance.

Fig. 40 introduces another element which causes the viewer's eye to be drawn to the focal point of the painting: this time it is the movement of light which directs you to an escape point on the horizon.

Fig. 40

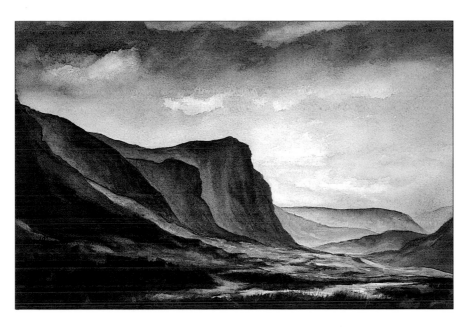

Movement of Light, Glen Coe, Scotland

You can see clearly that this is an L-shaped composition: the mountains on the left create the 'leg' of the L and the flat moorland forms the 'foot'. This framework holds the painting together but allows the eye to escape into the distance.

Above Wessenden Moor

This painting shows a Z composition, the most difficult of all. The eye travels down the path, reaches the edge of the moorland in the middle distance, and then traverses to the left, before being pulled to the right by the light in the distance. The sky also draws the eye towards the right. This zig-zag composition gives the painting its feeling of orchestrated movement and rhythm.

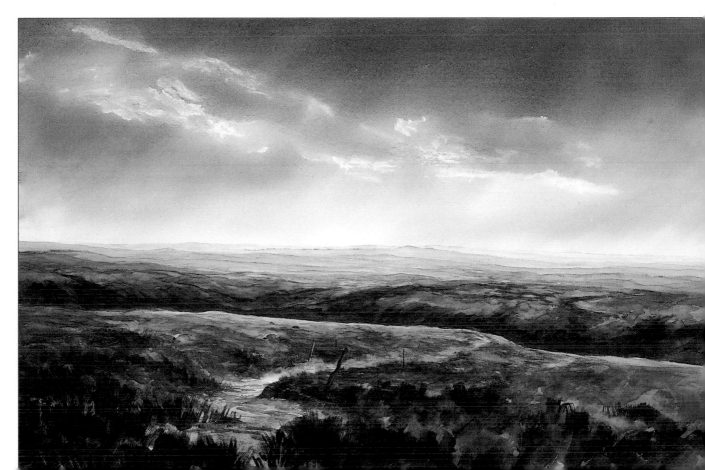

Low Cloud, Gordale Scar

Gordale Scar is one of the most picturesque beauty spots in Yorkshire. J.M.W. Turner depicted the scar as a huge crevasse, to convey the tremendous and overwhelming impression it made upon him. Knowing he had painted this scene gave me a real thrill and inspired me to paint this dramatic landscape.

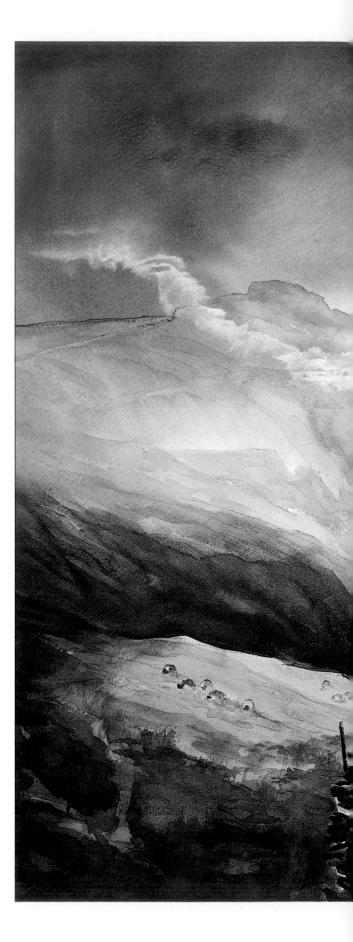

Low Cloud, Gordale Scar, Saunders Waterford 140 lb Rough, 50 × 75 cm (20 × 30 in)

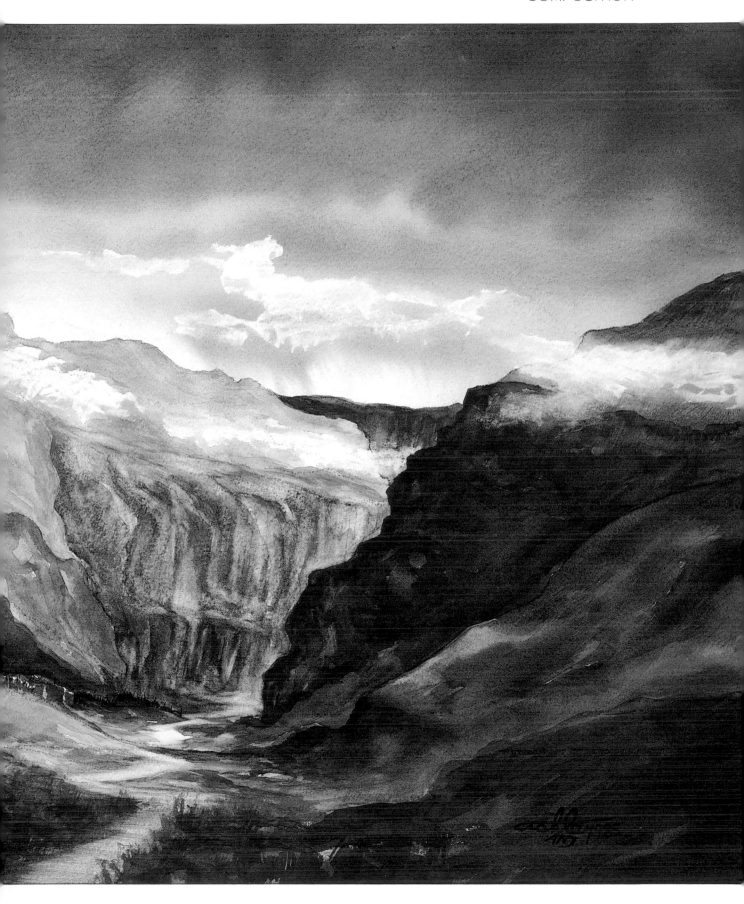

Saddleworth Moor

Many artists would have ignored this scene, as it seems to contain no obvious focal point of interest. The main feature is the wooden path of palings, which are like miniature railway sleepers, running across the moorland. What attracted me, however, was the challenge of trying to get down on paper the atmosphere of the place, the cold and the damp, and to translate these natural elements into paint. Once you have achieved this, you are well on the way to calling yourself an artist.

Colours and paper used: Prussian Blue, French Ultramarine Blue, Burnt Sienna, Raw Sienna, Lemon Yellow and Crimson Alizarin; Saunders Waterford 140 lb Rough.

Drawing

This is my original sketch for the painting of Saddleworth Moor. Notice the arrows indicating the direction of light and emphasizing the line of the path across the moorland, which draws the observer's eye into the painting.

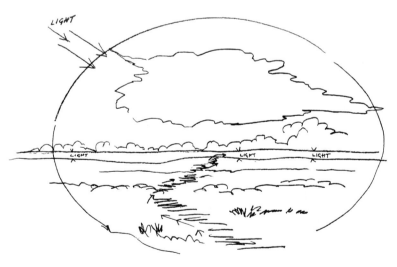

Fig. 41 Preliminary
drawing

Stage One

As usual I started with the sky, first damping the area with clean water applied with a wash brush. However, on this occasion I left dry a patch of sky where I wanted to have a large cloud formation. I then mixed the two blues with Crimson Alizarin and a pin-head of Burnt Sienna and put in the initial wash for the sky, gradually letting the colour get weaker as I worked down towards the horizon and avoiding the white cloud area. Before the wash dried, I took a damp brush loaded with clean water and softened the edges of the sky wash around the cloud area. Just above the horizon I applied a pale wash of Burnt Sienna mixed with a little Raw Sienna to give the picture some warmth. Then I added an initial wash to the foreground and middle distance, using the same colours as for the sky and leaving pre-planned areas of white paper to form the path.

Stage Two

At this point I applied my foreground and middle-ground washes, using Burnt Sienna and Raw Sienna initially in the foreground and adding French Ultramarine Blue and Prussian Blue, with a touch of Lemon Yellow, for the grassy areas in the middle distance. I weakened the tones near the horizon, but added more washes where shadows occurred.

Stage Three

Here I concentrated on painting the pathway. I carefully mixed Burnt Sienna and Raw Sienna, with a touch of French Ultramarine Blue, until I had just the right colour for the palings and the immediate foreground. Using my detail brush I then cut in individual palings, leaving areas of white around each one to emphasize its shape and suggest reflected light. Next, moving to the middle distance, I mixed Prussian Blue, French Ultramarine Blue and Lemon Yellow and gave this area a further wash to sharpen the contours.

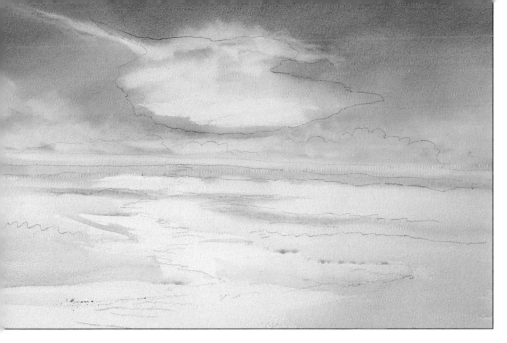

Fig. 42 Stage One

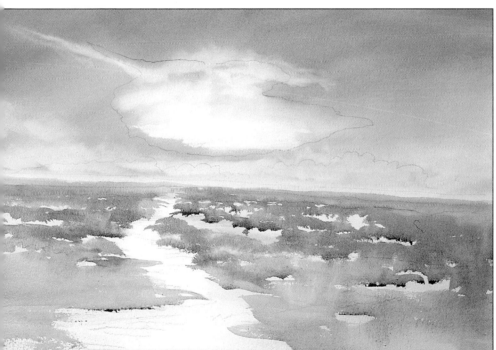

Fig. 43 Stage Two

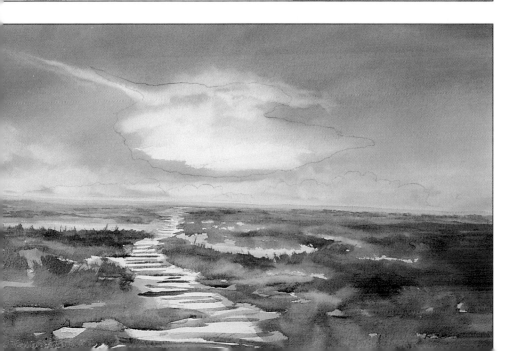

Fig. 44 Stage Three

Final Stage

With a mix of French Ultramarine Blue and Prussian Blue, and using my detail brush, I worked on the foreground, particularly in the area of the palings where I used these colours to enhance the shadowy side of the pathway. I added a fence post in the right-hand foreground to provide a little height and depth in what is basically a very flat landscape. I then reworked the foreground corners with my shade colour – the two blues and Burnt Sienna – to create depth and shadow here as well. By leaving white areas in the middle distance, I have tried to give the illusion of standing water on the moor. Finally, I added some individual blades of grass with a fine detail brush and incorporated a few more fence posts on the horizon.

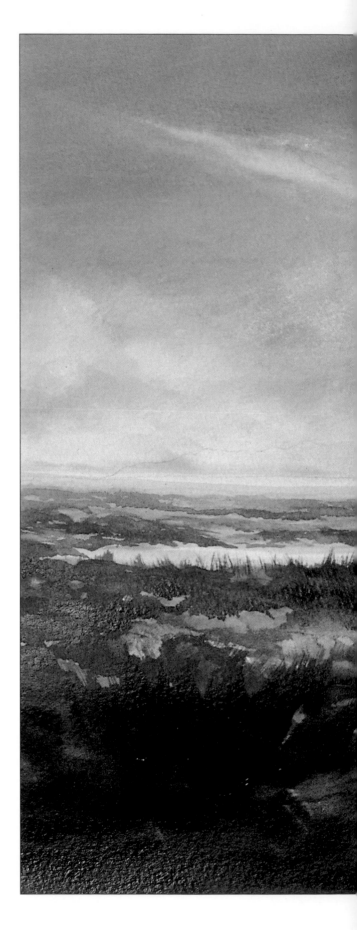

Fig. 45 Final Stage: *Saddleworth Moor*, 50 × 75 cm (20 × 30 in)

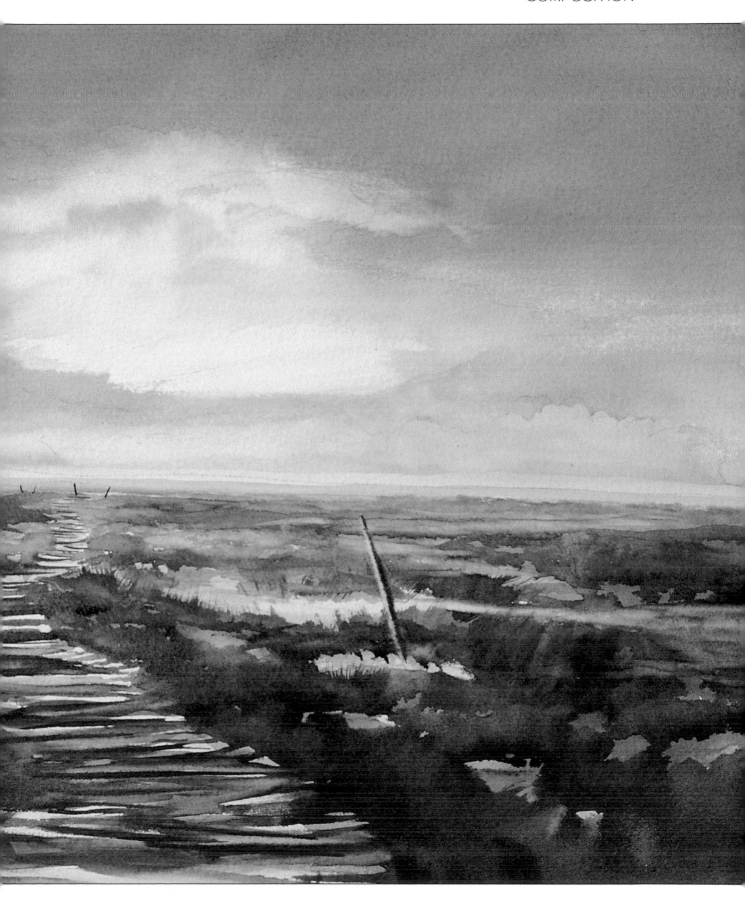

7 PAINTING SKIES

Skies are probably the most important element in my paintings. Many artists concentrate on foreground detail and put in the sky almost as an afterthought. I don't. I treat my landscapes as stage sets with the sky as the theatre lights, producing a range of colour and tone that creates the setting and mood for each of my paintings.

However dark a day may be, it is the light from the sky that affects the colour of the land, determines where the shadows fall and, finally, provides a key colour to be used throughout the whole painting. Getting the sky right in the first place is the critical factor in creating the final atmosphere of the painting. The sky should always be painted with care and respect because it is the real foundation on which a good painting is built.

I have already explained what a key colour is (see page 54) and it is particularly important to use one when painting landscapes. Without a key colour in a painting, the sky, background and foreground can often look as though they were painted in three separate locations on three separate occasions. It is only the use of one key colour throughout the work that holds the different elements together.

You should treat your sky almost as a separate painting, seeing it in terms of foreground, middle distance and distance. By doing this you will increase the interest and feeling of depth in your work.

When painting a sky, remember to use the 'windscreen wiper' technique I described earlier and to create cloud formations by pulling out white areas with your brush. Strokes of a soft wash brush, applied while a sky wash is still wet, can be used to portray rain, and a dry chisel-edged brush can be effective for putting in sunrays.

I always paint with my easel almost vertical. (I was trained as a sign-writer so painting vertically comes naturally to me.) This has the advantage of allowing the sky and other washes to flow down the paper, often creating spectacular effects. However, a great deal of control in mixing the wash is needed and this comes only with experience. Painting horizontally has its problems, too, as then you have to push the colour around the painting. My advice is to tilt your easel to an angle of 45 degrees when you start to paint. This will give you more control over the moving colour.

'Moorland Grit', Beamsley Beacon

Who would have thought you could see brown in a sky! This atmospheric painting shows the rain clouds being blown quickly across the sky by the wind; again, the sense of movement is achieved by painting the sky at an angle.

Rain on Flush House Moor

Strange how this one happened. I decided to spend the day up on the moors above my house in Holmfirth, Yorkshire, but the weather became so bad that even I abandoned my easel in favour of the moorland pub. When I was finally poured out by the landlord at 3 p.m. the weather had improved slightly and, fortified by the courage of a Dutchman, I walked just a short distance over the moorland and came upon this scene with its highly dramatic sky. It was still raining 'moorland grit' so I had to work quickly; in fact, you will notice that a couple of the telegraph poles are not quite straight, due entirely to the strength of the wind and rain (or possibly the hours spent in the pub) and the fact that I had only one chance to lay the colour because I could not keep my paper dry.

A national newspaper once christened me 'the patron saint of telegraph poles'! Here I think they provide a sense of man-made power and energy struggling against the forces of nature. The 'window in the sky' is an integral part of the composition: the light which breaks through the dark clouds highlights the detail in the middle foreground.

PREVIOUS PAGES:
Cephalonia, Greece,
Saunders Waterford
140 lb Rough,
50 × 75 cm (20 × 30 in)

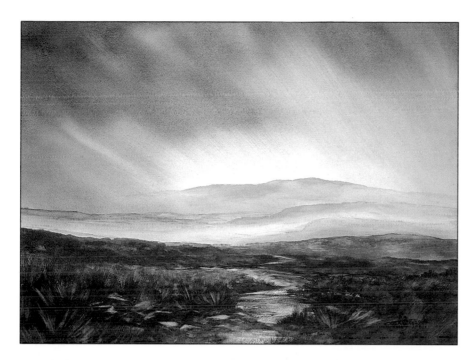

'Moorland Grit',
Beamsley Beacon,
Saunders Waterford
140 lb Rough,
50 × 75 cm (20 × 30 in)

BELOW: *Rain on Flush
House Moor*, Saunders
Waterford 140 lb
Rough, 50 × 75 cm
(20 × 30 in)

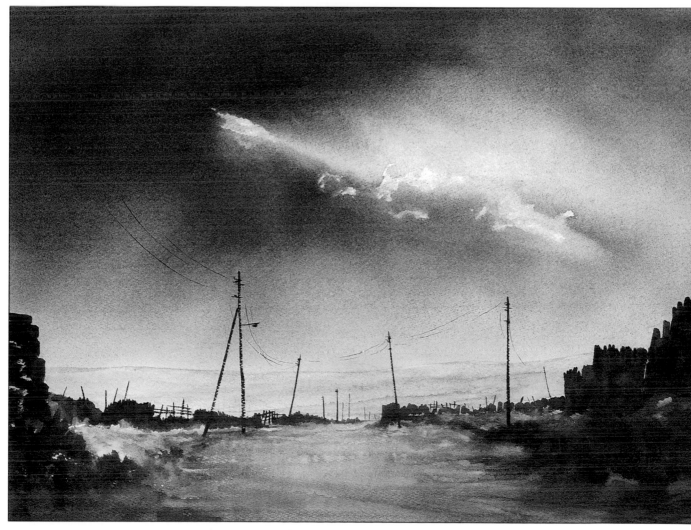

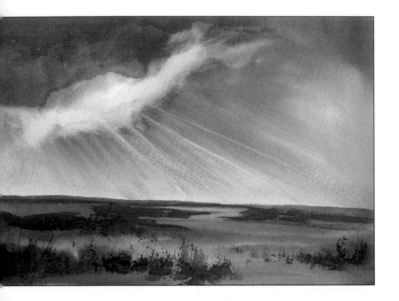

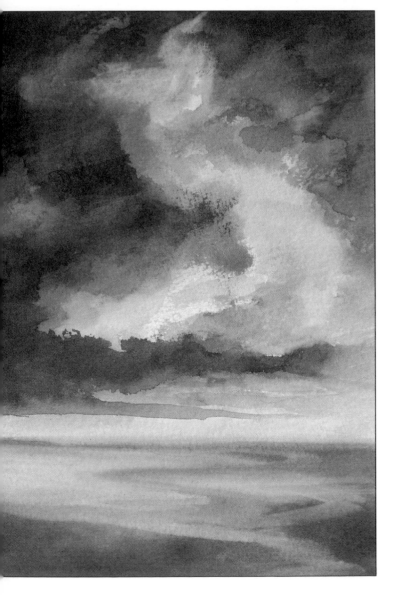

Different sky effects

The following nine illustrations show some of the many different types of sky you may see when you are painting in the open air. Fig. 46 shows a sky filled with storm clouds. On an angry day like this you often see 'windows of light' appearing in the sky, shooting rays onto the landscape almost like spotlights in a theatre. Although the light changes constantly in this type of weather, you must suspend the picture in your mind and try to achieve the effect of moving light over the land by creating areas of shadow right across the picture.

In Fig. 47 light hits the painting from two sources: the spotlight 'window in the sky' and an area just above the horizon. This second source produces what I call the 'saucepan lid' effect: the sky appears to have been raised slightly from the earth just as a lid might be from a pan. The diffused light has a softening effect on the harsher spotlight beam coming through the clouds, making the atmosphere of the whole painting more mellow.

Fig. 48 shows the 'saucepan lid' effect and a calm, still sky. Here the light skates across the landscape, giving you the feeling that it is coming in from all angles.

The type of sky seen in many mountainous regions is illustrated in Fig. 49. I often paint in this kind of situation and my favourite description for rain like this is 'moorland grit' – harsh little droplets that appear rather innocent initially but which after a couple of hours soak you to the bone. Despite the wetness, this particular type of weather and climatic effect is absolute magic for creating the fantastic, atmospheric conditions that I love to paint.

TOP LEFT: **Fig. 46** Rays of light through storm clouds

LEFT: **Fig. 47** 'Windows in the sky'

Fig. 48 A calm, still sky

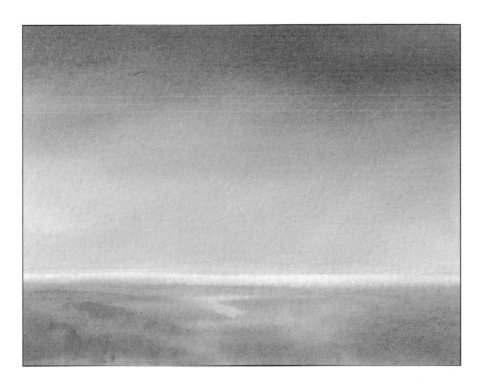

BELOW: **Fig. 49** Pouring
rain

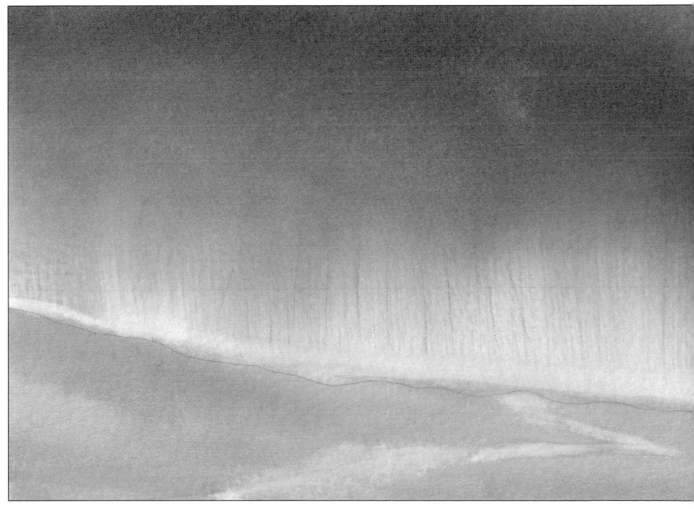

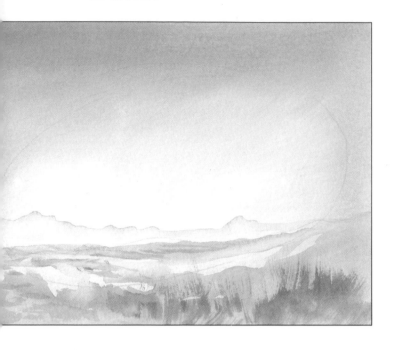

Fig. 50 Misty effects

Painting in misty conditions is a great help to the novice painter, as it helps him to understand the 'blue glass' theory. Over the years, I have tried to explain recession to students by making them imagine sheets of blue glass set up at regular intervals. The more sheets of blue glass they look through, the weaker the colour and tones become. Mist creates this effect naturally, acting like a filter on a camera. Notice how the colour in Fig. 50 becomes paler and paler as it recedes into the background.

In theory, rain should fall vertically. However, it seldom does because it is blown by the wind. To achieve the effect of driving rain, as in Fig. 51, paint your sky at an angle, making sure that the trees and grass also bend in the wind.

Fig. 52 is a semi-monochrome which shows you how to achieve the effects of a sunset in a warm climate. Yellow and orange tones are used to suggest a feeling of heat. Note the long shadows, the heat haze, and how the colour of the sky affects the whole picture. Even the seagulls take on a warm glow.

It is worth noting here that in hot countries the sky can look very different at various times of the day. In the coolness of early morning it may appear blue, as in *Cephalonia, Greece* on pages 80–81, for example, but by midday it generally appears bleached out and flat.

The sky in Fig. 53 should remind you of a warm summer's day. The bright light is created by the sharp contrast between the white clouds and the blue sky, and is emphasized by the white area above the horizon.

You probably think that this example is a little odd (Fig. 54)! Often, however, in the great outdoors mist develops into fog, creating a strange and eerie effect that can make for a very different kind of painting. To give the impression of fog here I applied a graduated wash from the top, then put in another graduated wash from the bottom upwards, leaving a delicate band of light in the middle to show through gently. This is a very good exercise in control of washes.

Fig. 51 Driving rain

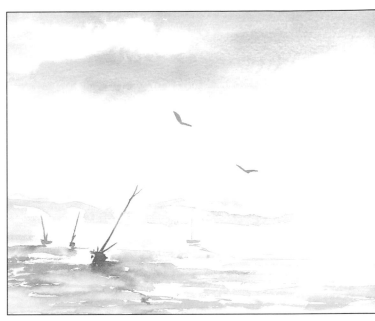

Fig. 52 Sunset in a
warm climate

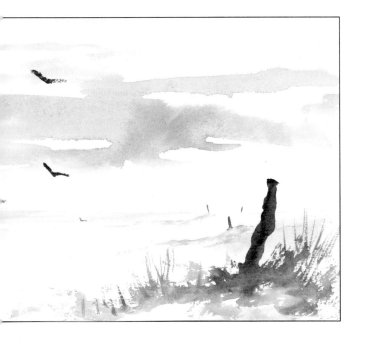

Fig. 53 A bright,
summer sky

Fig. 54 Fog

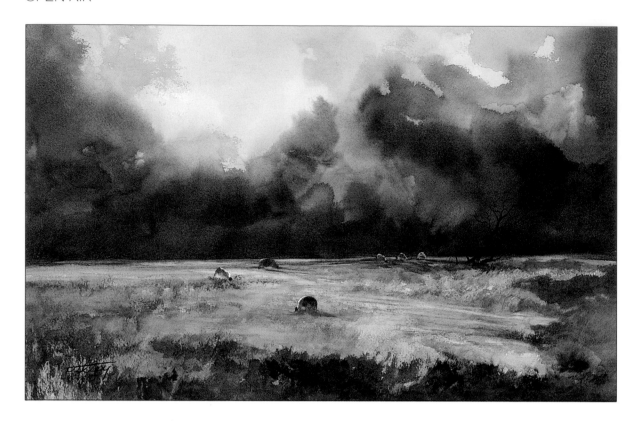

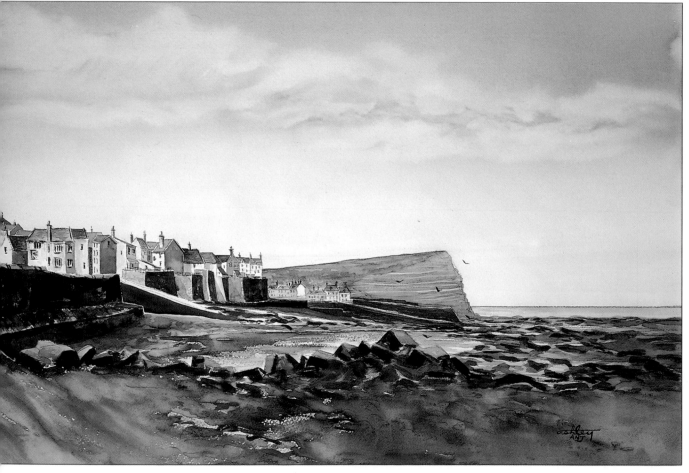

Eerie Day, Wycliffe,
Near Barnard Castle,
Saunders Waterford
140 lb Rough,
50 × 75 cm (20 × 30 in)

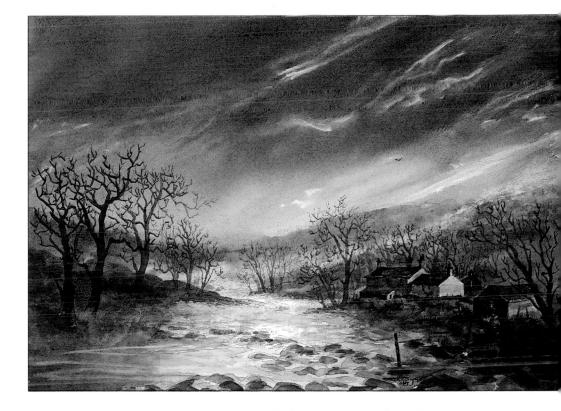

OPPOSITE: *Angry Sky*,
Saunders Waterford
140 lb Rough,
50 × 75 cm (20 × 30 in)

OPPOSITE BELOW: *Staithes,*
Yorkshire, Saunders
Waterford 140 lb
Rough, 50 × 75 cm
(20 × 30 in)

Angry Sky

In this powerful, atmospheric painting I wanted to show that although the ground is flat, it is also high up on the moor. To give a suggestion of height I made the very dark, indigo blue sky come right down to the horizon. The 'window' in the clouds reflects light from the sky onto the ground, which also has the effect of seeming to link the two more closely.

Staithes, Yorkshire

This painting is from my television series *A Brush With Ashley* and was painted at the lovely fishing village of Staithes on the north-east coast of England – the place, incidentally, where Captain James Cook lived as a boy. I have tried to capture the quality of light on a fine summer's day, marrying it with the dampness of the rocks in the foreground, which provide a foundation for the colourful houses on the shore. A feeling of stillness was created by painting the sky horizontally. Before you question my 'black' seagulls, go and look at them against a bright summer sky: they really do appear as silhouettes.

Eerie Day, Wycliffe, Near Barnard Castle

Thinking about this painting makes my hair stand on end. I had decided to look for this particular spot knowing that my idol, J.M.W. Turner, had painted it years before me. On the day I arrived the mist was very heavy, and as I came to the foot of the valley the wind suddenly got up and started to blow the mist around, creating a rather eerie atmosphere. I used dark colours for the sky to reflect the mood of the place and as a contrast to the lighter colours in the foreground. Notice how the angle at which I painted the sky suggests the movement of the wind.

Although there is a small hamlet nearby, I never met another soul while I was there; the only sign of life was the movement of light behind slightly open curtains as I passed by. I felt like a thief stealing from the community, taking away a little bit of its spirit in my painting – a strange, but nevertheless interesting experience.

Greenfield Moor

The sky in this painting was a very difficult one to paint as it was virtually cloudless and yet I still had to get across the dampness and heaviness of the atmosphere. Because there are no vertical lines in this landscape, it was also extremely hard to create a feeling of depth within the painting. Only controlled colour perspective and tone were able to achieve this.

Colours and paper used: Prussian Blue, French Ultramarine Blue, Crimson Alizarin, Lemon Yellow, Raw Sienna, Cadmium Yellow and Burnt Sienna; Saunders Waterford 140 lb Rough.

Drawing

This is virtually a non-drawing because of the amount of standing water in the painting. It is really only a flavour of the work as opposed to a detailed layout. It does, however, include arrows to show the direction of the light.

Stage One

To achieve the feeling of a damp atmosphere I really soaked the sky area with clean water and quickly mixed Prussian Blue and French Ultramarine Blue, with a touch of Burnt Sienna and Crimson Alizarin, until I had just the right bluey grey colour. Still working quickly, I laid the colour over the wet paper with my wash brush, using the 'windscreen wiper' technique and increasing the amount of water in the wash as I travelled down towards the horizon. I was very careful not to let any colour run into the moorland. Next, I dampened the areas of standing water in the painting and put in the lightest sky tones so that these areas reflected back up to the sky like sheets of glass. I then let the washes dry naturally. Once the paper was reasonably dry, I took some of the bluey grey sky colour and laid in the distant hills on the horizon. Then I mixed Lemon Yellow and Prussian Blue for the grassy areas in the middle distance and foreground.

Stage Two

With my wash brush and using the sky mixture, but with added Prussian Blue, I repainted the hills on the horizon to give them more definition. Then, adding more Crimson Alizarin to the sky colour, I filled in the shadows and contours of the middle distance.

Stage Three

I applied another wash, of French Ultramarine Blue, Crimson Alizarin and a touch of Prussian Blue, to the middle distance and foreground, avoiding the areas of standing water. I also started to put in a few tufts of grass in the foreground.

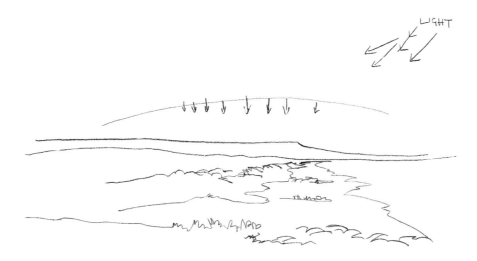

Fig. 55 Preliminary drawing

Fig. 56 Stage One

Fig. 57 Stage Two

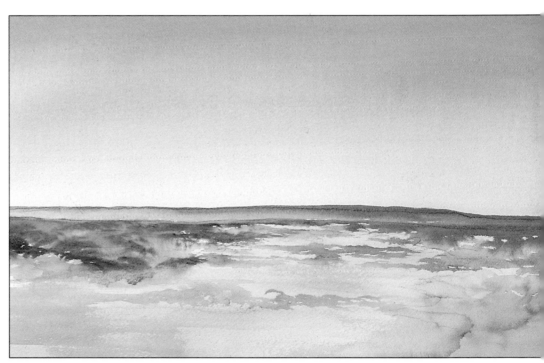

Fig. 58 Stage Three

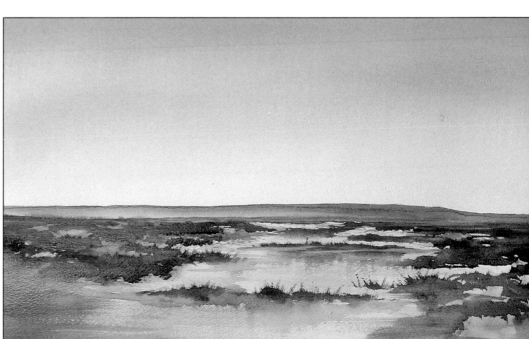

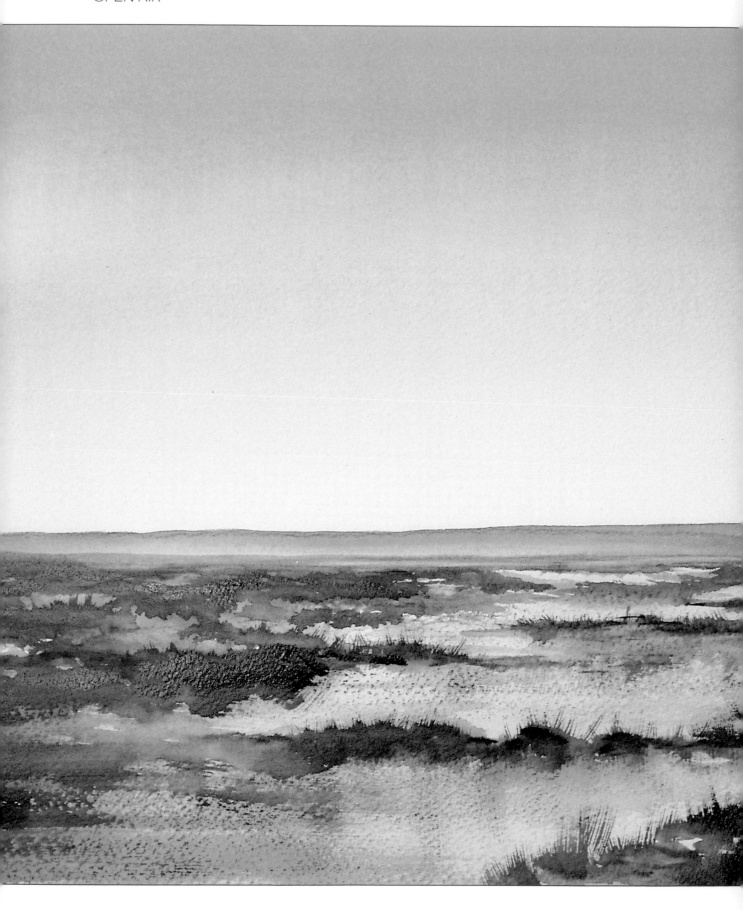

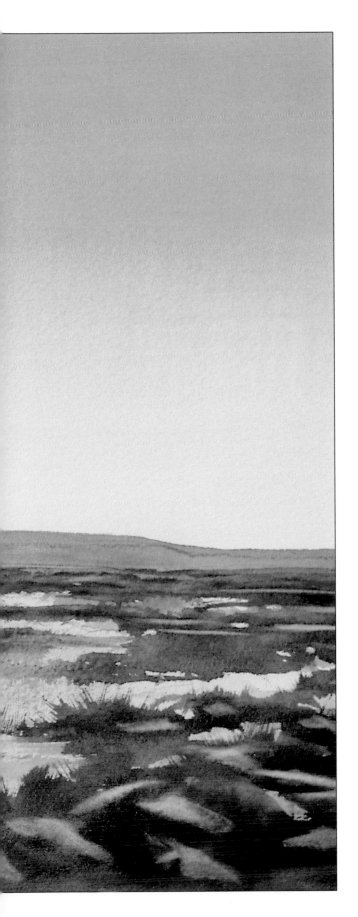

Final Stage

When everything was semi-dry I shaped the foreground boulders, using Burnt Sienna and French Ultramarine Blue, pulling out colour where reflections of light occurred. Then, with Prussian Blue, French Ultramarine Blue, Burnt Sienna and a touch of Crimson Alizarin, using a medium-size sable brush, I worked upwards on the grass tufts, creating individual blades. Finally, with the same brush and the same colour mix, but using virtually no water, I worked on the watery areas in the painting, making vertical strokes in order to simulate reflections.

Fig. 59 Final Stage:
Greenfield Moor,
50 × 75 cm (20 × 30 in)

93

8 PAINTING WATER

Water is probably the most daunting element of the landscape as far as the artist is concerned. To portray it convincingly you need to combine good technique with an understanding of how water moves and how it is affected by sunlight, moonlight, wind and all the other natural elements it comes into contact with.

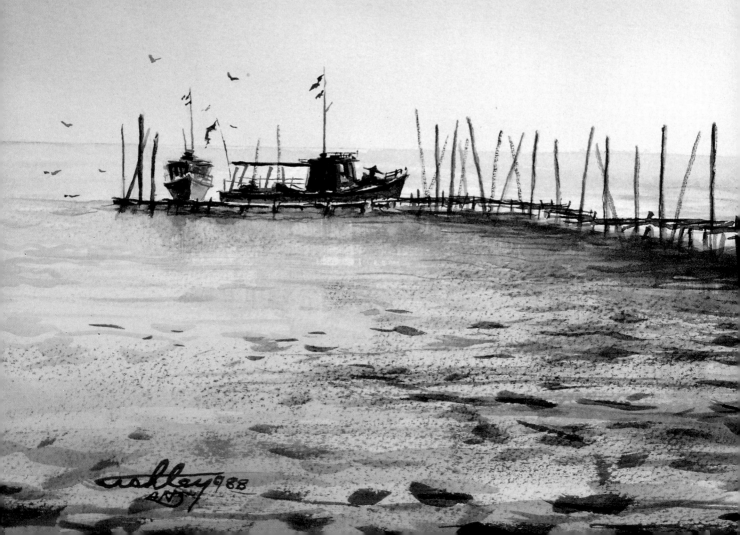

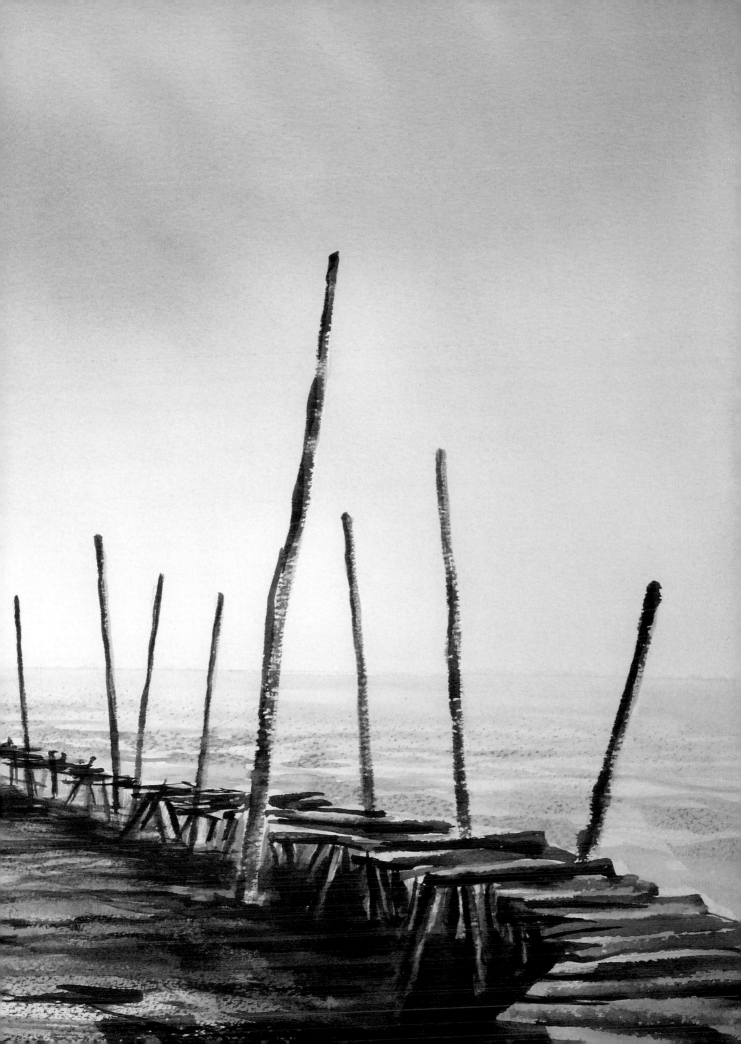

PREVIOUS PAGES: *Boats,
Teluk Bahang, Penang,
Malaysia*, Saunders
Waterford 140 lb
Rough, 50 × 75 cm
(20 × 30 in)

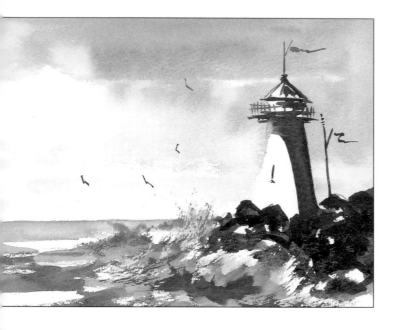

Painting water presents all kinds of practical difficulties. How, for example, do you make a placid lake look still and calm? How do you put movement into a running stream in a static landscape? How do you give the impression of real depth in a lake? How do you make falling water look authentic? How do you portray waves and seaspray?

All these problems face the artist, and only by studying water in all its forms and practising your technique will you feel comfortable and confident when attempting to incorporate water into your paintings. I have devised some simple exercises which I hope will help you gain the necessary confidence.

Fig. 60 shows a lighthouse standing on the shore of a rocky coastline. The sea is very rough and waves cascade onto the rocks. In order to suggest the movement of the waves and the seaspray I used the technique previously described for painting grass tufts (see page 34). After applying the basic washes I loaded my colour onto a dry chisel-edged brush and, using sharp, upward movements,

TOP: **Fig. 60** Seaspray

ABOVE: **Fig. 61** Falling water

Fig. 62 Flat, calm water

put in the spray, rather like creating blades of grass. Remember, when making the initial washes, to leave areas of white paper to represent surf and reflected light.

When portraying a waterfall, as in Fig. 61, the novice can be tempted to paint the water on a flat plane, like painting a door. Don't, otherwise what you will end up with is something looking like exactly that! Study the movement of water as it falls. Note that it does not fall absolutely vertically. Find the contours as you would in a landscape and make your brush strokes follow the flow of the water, leaving white areas to emphasize the movement.

The monochrome in Fig. 62 illustrates how to paint the sea from a boat looking towards the shore. The exercise shows how to make the sea appear to be on a flat plane whilst at the same time retaining a sense of movement and perspective. This is achieved by first finding the pattern of reflected light on the water. Almost like a path in a landscape, this will lead the eye into the picture,

and by using larger areas of reflection in the foreground and smaller ones in the distance, you can create a feeling of depth in the painting. You then put in the sea, using horizontal strokes of a medium sable brush to give the impression of flatness.

Try turning your monochrome upside down: because the light from the sky is reflected on the sea, the point of entry into the painting which appears in the sky should be mirrored in the sea.

Unlike oils, watercolours are less forgiving of mistakes. When trying to combine shadow and reflections on a large surface of still water, such as illustrated in Fig. 63, it is necessary to put in the lighter, reflective areas first. In other words, work from light to dark. If you try to do it the other way round, you will end up with an awful lot of expensive watercolour paper in your waste-paper bin. Use horizontal wash strokes to put in shadows; vertical strokes of a dry brush for reflections.

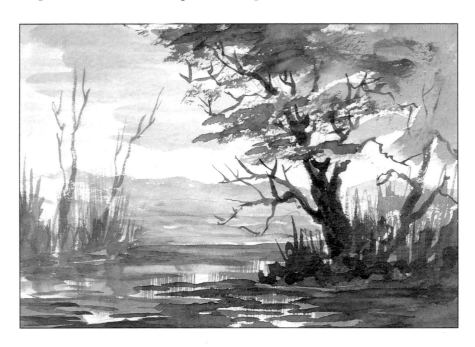

Fig. 63 Reflections of light on water

97

Rushing Water, Isle of Skye
I always wanted to visit the Isle of Skye
and a couple of years ago I was given the
opportunity to go there with a friend of
mine who is a skilled photographer. I was
immediately bewitched by the majestic
scenery, especially the mountains and
seascapes, and in just a few days had
painted a whole series of watercolours
inspired by the beauty of the isle.

 To capture the feeling of ice-cold,
rushing water in this painting I used pale
tones of blue and left several areas of white
paper. I found the mountainous areas
easier to paint than the high plains of my
native Pennines, because the peaks offered
natural recession.

*Rushing Water, Isle of
Skye*, Saunders
Waterford 140 lb
Rough, 50 × 75 cm
(20 × 30 in)

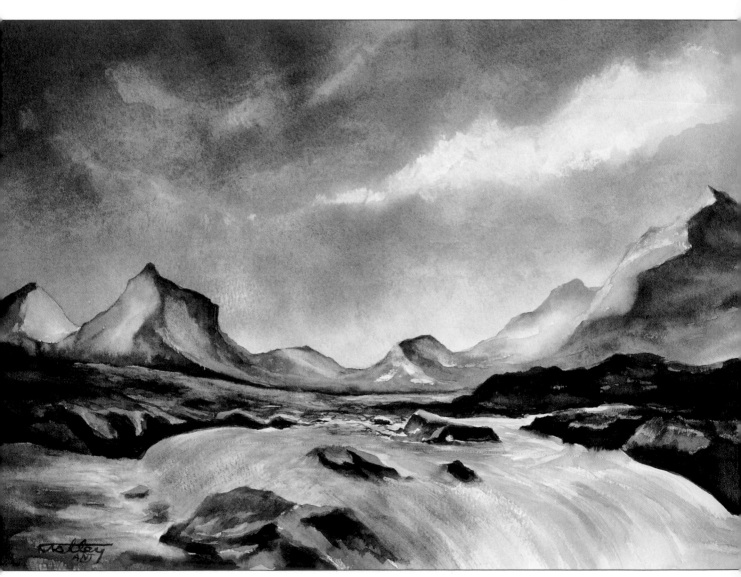

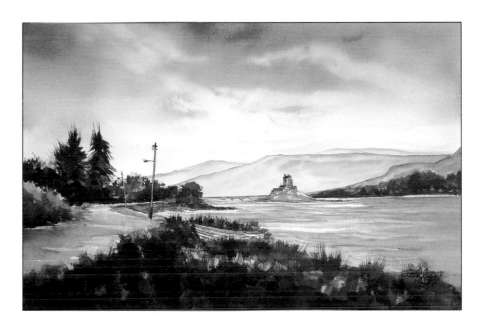

The Road to the Isles,
Saunders Waterford
140 lb Rough,
50 × 75 cm (20 × 30 in)

The Road to the Isles

Locations are funny things: sometimes you can spend days searching for just the right picture and just the right angle; at other times, it will smack you in the face.

On my way back from the Isle of Skye I motored round a bend and there it was – the perfect composition laid out before me: an interesting sky, an unusual focal point in the island castle, the still water of a Scottish loch, and a road on the left that led into the picture. Why, it even had my favourite feature – a telegraph pole – in the foreground! An absolute natural. I stopped and painted it there and then. Notice how the impression of calm, reflective water is created by the horizontal streaks of white paper within the wash.

Isle of Skye

This was painted on a changeable day on Skye, up in the Cuillin mountains. The strength of this composition comes from these dramatic peaks, but the way in which the water weaves its path around the rocks in the stream gives your eye time and space to view the whole panorama. A picture full of drama and beauty.

Isle of Skye, Saunders
Waterford 140 lb
Rough, 50 × 75 cm
(20 × 30 in)

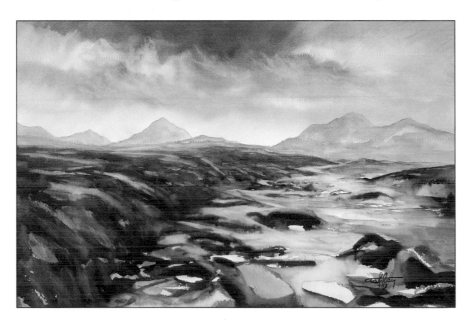

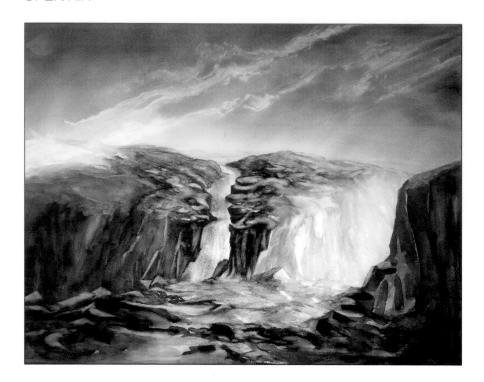

Cauldron's Snout,
Saunders Waterford
140 lb Rough,
50 × 75 cm (20 × 30 in)

Cauldron's Snout

It started as a labour of love and ended like an expedition to the Antarctic.

Ever since I saw Turner's painting of Cauldron's Snout in Teesdale, I had wanted to paint it. I set off early one bleak winter's morning with a friend on the 24-km (15-mile) climb to the Snout from High Force. Normally, the journey takes about four hours, but in this case, hampered by driving snow and high winds, we did not arrive until late afternoon. With the light fading fast, and fingers freezing to my brushes, I got down on my paper as much information as I could before the light finally beat me. Even though I have travelled to very cold countries in the past, I have never experienced the raw, bone-numbing cold that I felt on that day, which I have tried to capture in the painting. But it was worth it: I prize this particular painting and doubt whether I would ever sell it.

When Turner, all alone on horseback, painted this scene the local innkeepers used to hire out socks warmed in their ovens to passing strangers. We would have given a king's ransom for a couple of pairs that day.

Janet's Foss

This lovely place is not far from Gordale Scar in North Yorkshire. Whilst the surrounding countryside is wild, open and rugged, this beautiful little wooded area provides a haven for the local wildlife and looks typically English, particularly in its spring clothes. The painting, with its rich, warm greens, always gives me a feeling of peace and tranquillity, and reminds me of home when I am away on my travels around the world.

Gas Rig, North Sea

I flew out in a helicopter to this rig, which represents man's survival against nature and the elements. It is a hostile environment, one of wild seas and high winds. I used tonal perspective to depict the swell of the ocean but I did not put too much fine detail into the sea, wanting to reserve this for the gas rig itself. This is a good example of an L-shaped composition.

Janet's Foss, Saunders
Waterford 140 lb
Rough, 50 × 75 cm
(20 × 30 in)

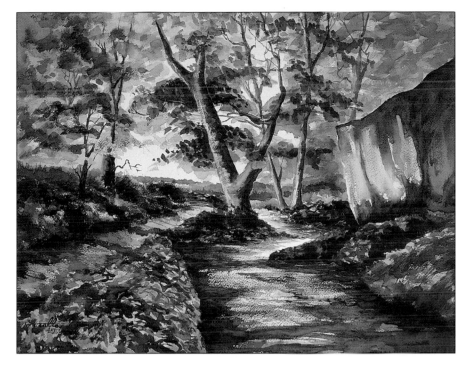

BELOW: *Gas Rig, North
Sea*, Saunders
Waterford 140 lb
Rough, 50 × 75 cm
(20 × 30 in)
(By kind permission of
British Gas)

Fig. 64 Preliminary
drawing

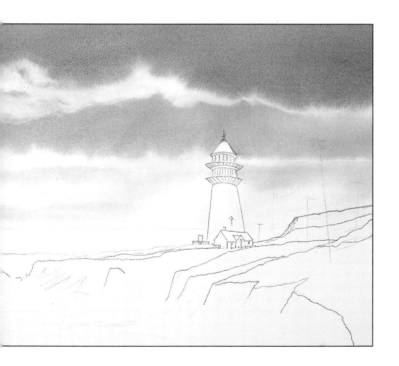

Fig. 65 Stage One

Coast Lighthouse, Oregon
Apart from the lighthouse itself, I was
originally attracted to this scene by the red
corrugated-iron roof of the lighthouse
keeper's house, which stood out clearly
against the blues and greens. The sea was
also quite dramatic, with a good deal of
surf running against the rocky headland.

Colours and paper used: French Ultra-
marine Blue, Prussian Blue, Crimson Alizarin,
Burnt Sienna, Cadmium Yellow and Raw
Sienna; Saunders Waterford 140 lb Rough.

Drawing
This is an L-shaped composition. I drew a
very light but quite detailed outline of the
lighthouse and the headland, the focal point
of the work, but left the atmospheric sky and
water until I started painting.

Stage One
On the day I painted this scene the sky was
grey and laden with rain, but there was a
hint of redness in it. In order to achieve this
colour, I used the two blues in my palette,
together with a pin-head of Crimson Aliza-
rin, and experimented in the margin until I
had just the right colour mix. This gave me
the confidence to build up the painting from
the sky, using this colour as my key colour.
With clean water on a large wash brush, I
covered the surface of the sky area. I applied
the grey colour I had just mixed to the top of
the painting, using the 'windscreen wiper'
technique. I allowed the colour to get lighter
as it neared the horizon and I cut in carefully
around the lighthouse. Then, using the same
wash brush, slightly dampened, I pulled out
the clouds.

Stage Two

Mixing an equal amount of Raw Sienna and Cadmium Yellow, I painted the heathland in front of the lighthouse, using a large sable detail brush. I then painted the right foreground, using the same colour but adding Prussian Blue to the mix to create some shadow and give the impression of cloud movement/reflection. While the near foreground was still wet, I mixed Cadmium Yellow, Prussian Blue and a touch of Raw Sienna and dropped it in to emphasize the shadow effect, using the wet-into-wet technique.

Stage Three

This stage is where the painting starts to come alive. To paint the shadow areas on the cliffs and lighthouse, I mixed a slightly heavier tone of the original sky colour, using less water. I left white areas of paper for the surf, putting in only the dark shadows on the sea. For these I mixed the two blues, using about 70 per cent Prussian Blue because this contains a green hue, similar to the sea's natural colour. I achieved the feeling of the surf bashing into the cliffs by cutting in the rocks sharply. Using a weakened version of the sky colour I put in the sea on the horizon. I then picked up my fine detail brush and started to add some detail to the lighthouse, again using the sky colour but mixed with more pigment and less water.

Stage Four

The real detail emerges in this stage. Using my fine detail brush, loaded with Crimson Alizarin and a touch of Burnt Sienna, I painted in the red corrugated-iron roof of the house. Perhaps the most difficult part of the painting is that of conveying the impression of light filtering from inside the lighthouse. I achieved this by applying a Cadmium Yellow tint to the top part of the building. I then added my second wash to the foreground, using Burnt Sienna and Raw Sienna for the dead bracken on the headland. With a detail brush and using the sky colour, I put in the telegraph poles and the flag pole, which provide depth and draw the eye into the painting. I then rewashed the shadow areas of the

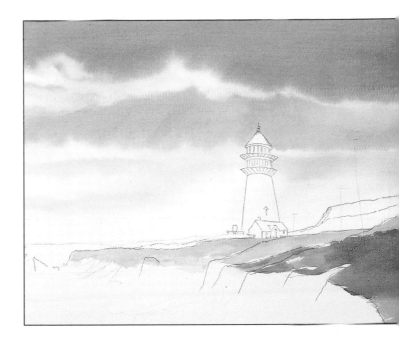

Fig. 66 Stage Two

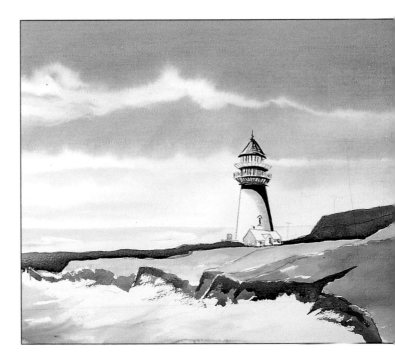

Fig. 67 Stage Three

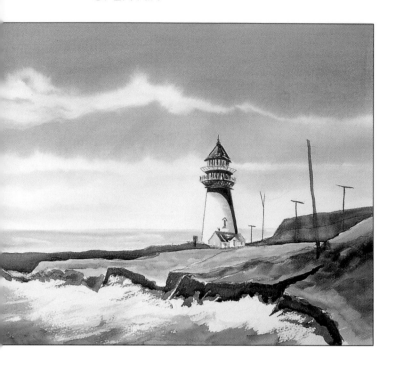

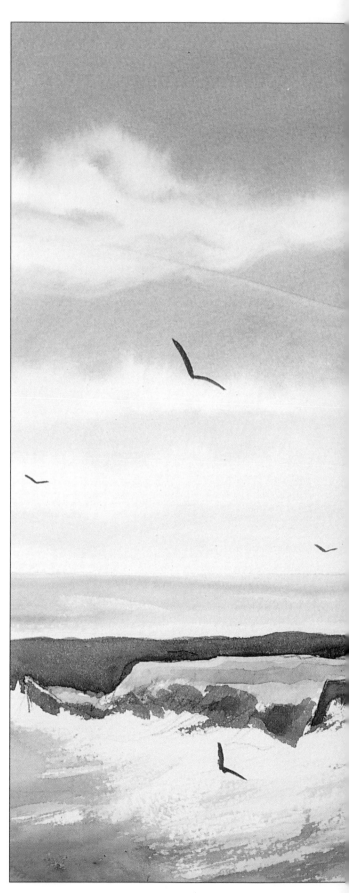

ABOVE: **Fig. 68** Stage Four

Fig. 69 Final Stage: *Coast Lighthouse, Oregon*, 50 × 75 cm (20 × 30 in)

sea, using the original colour. By adding another 'sheet of coloured glass', greater depth and interest can be created.

Final Stage

At this point, I examined the work to see where more detail was required, 'putting the shoelace to the boot', as I describe it. To show the light flashing across the sky from the lighthouse I used a pale mix of Cadmium Yellow, applying this very, very lightly over the sky and weakening the tone as the beam expanded outwards. Provided your sky colour is absolutely dry, you can skate over the surface with another colour on one occasion only without lifting the original colour. Using a damp chisel-edged brush, I then took out the colour on the sides of the telegraph poles to give the impression of reflected light. I applied my third 'sheet of glass' – that is, my wash – to the darkened areas of the sea, building depth with each layer of colour. Finally, with my fine detail brush I put in the flag, telegraph wires and the seagulls, dark against the sky.

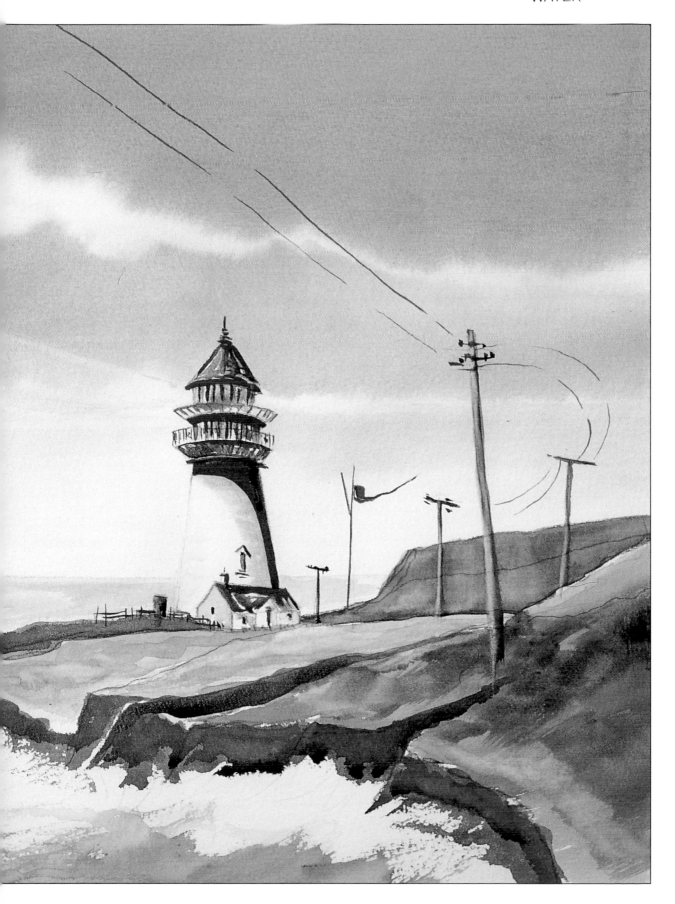

9 CAPTURING ATMOSPHERE

As you will have realized by now, creating atmosphere in your work is at the very heart of this book. However, it is probably the least easy aspect of painting to understand and achieve. You can create a picture by a purely technical process, but to create a painting, you have to convey to the viewer a sense of what it was like to stand in that place, at that time, and paint.

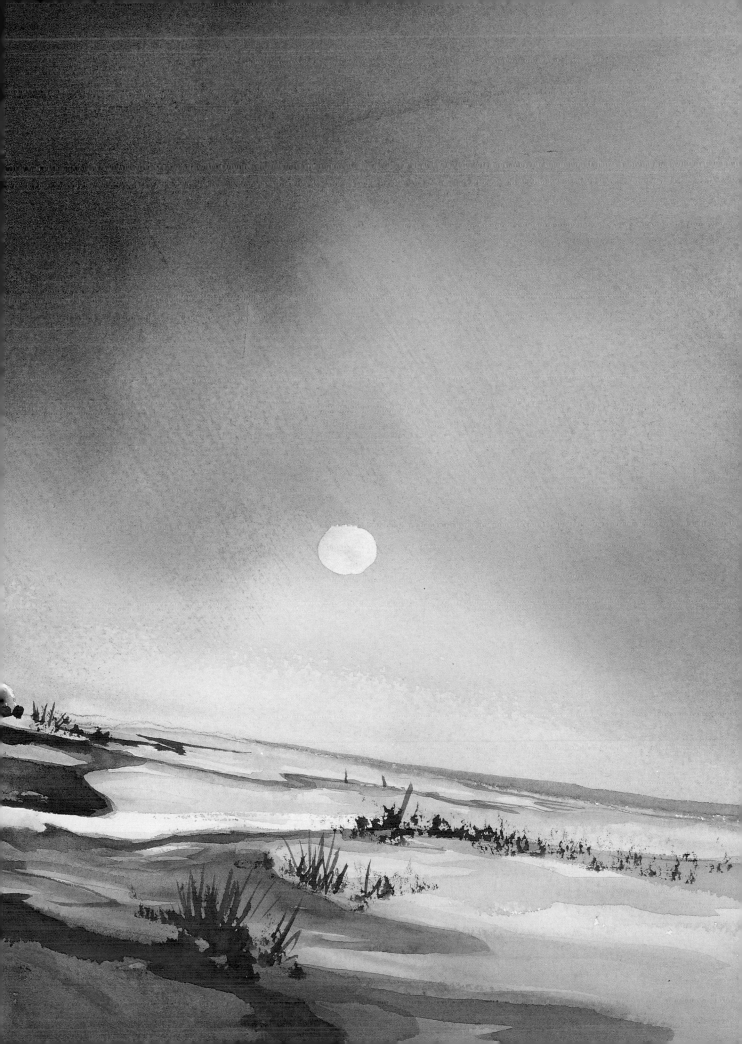

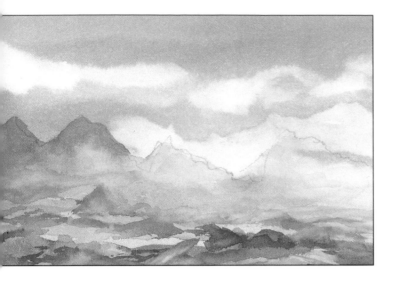

PREVIOUS PAGES:
Moonlight, Winter,
Saunders Waterford
140 lb Rough,
50 × 75 cm (20 × 30 in)

Fig. 70 This illustration captures the mood of a cold day in the mountains – you can feel the crispness in the air. The Prussian Blue used here provides that ice-cold colour so synonymous with winter landscapes. See how it weakens as it recedes into the cloudy background.

If you do not feel the atmosphere in one of my paintings, then I have failed as an artist because I have not captured the spirit of the landscape. Painting is not just about water, paint and brushes; it is about borrowing directly from the soul of nature, incorporating that extra ingredient into your painting which gives it a life all of its own. You will know when you have achieved this, and from that moment on, you can call yourself an artist.

In the six examples here, I have tried to re-create some of the atmospheric effects commonly experienced out in the open air, such as cold, heat, wind, rain and changing light, and which if portrayed accurately can give your work that special quality.

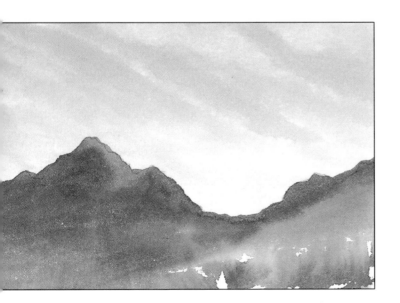

Fig. 71 When you want to portray a windy day in a picture, paint the clouds leaning over at an angle of 45 degrees so that they look as though they are being chased across the sky. Here you can sense the movement of the wind across the mountain tops, simply by observing the contours and highlights in the sky.

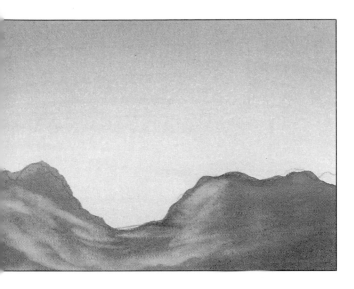

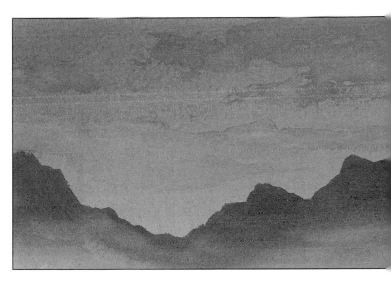

Fig. 72 The feeling of heat in this example is achieved by adding a little of the sky colour, Raw Sienna and Burnt Sienna, to the base colour of the rocks, Prussian Blue and Burnt Sienna. Notice also that by careful wash gradation, you can create the feeling of heat just above the horizon.

Fig. 74 Although this appears to be a monochrome, it contains a mixture of French Ultramarine Blue, Crimson Alizarin and Burnt Sienna. With just a limited amount of this colour, I have tried to create the atmosphere of dusk on a mountain top. By applying a graded wash the light appears to be trickling over the mountain tops, suggesting that the sun has just gone down over the horizon.

Fig. 73 This shows that by careful colour mixing – in this case, Prussian Blue, Raw Sienna and Burnt Sienna – you can create the effect of laden snow clouds, ready to unleash their energy onto the earth.

Fig. 75 Dusk and, in this case, dawn are probably the most interesting times to paint, as the light is at its softest then. Although you can never generalize, dawn tends to throw up misty blue tints while dusk reveals tints of Raw Sienna. At these times nature helps you to paint by emphasizing the way the landscape recedes in an early morning mist or an evening heat haze.

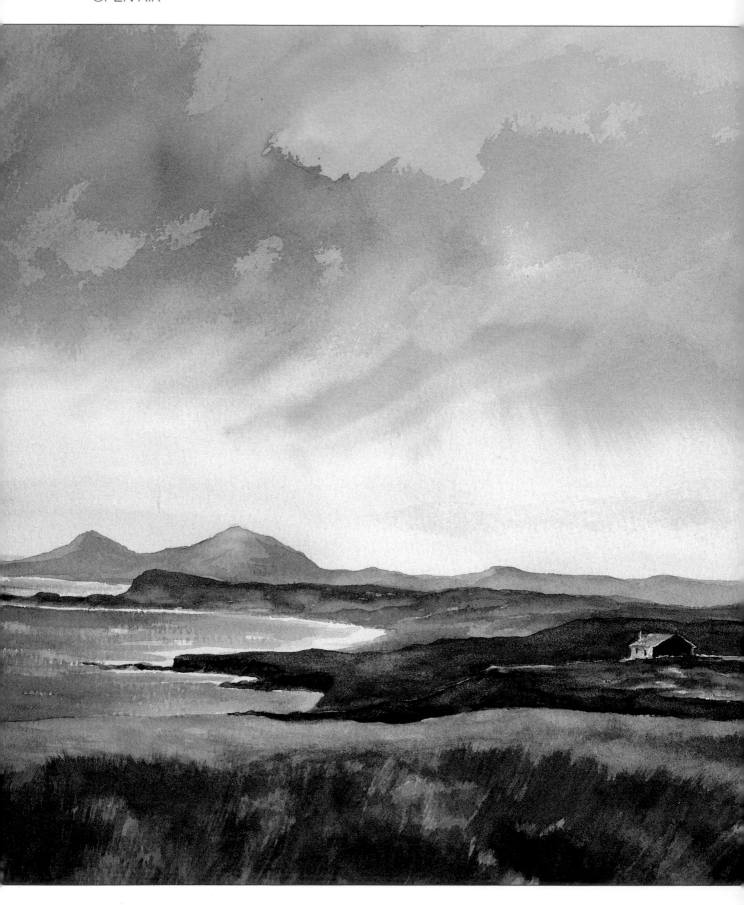

A Room with a View
Imagine pulling back your curtains every morning and seeing this view. I originally saw this cottage through binoculars from some distance away and was attracted to it by its red corrugated-iron roof, which stood out from the blues, greens and yellows of the heather and gorse. The scene had all the magic that only Scotland can offer, with its majestic mountains, wide vistas and wild coastline. A fabulous place to spend your days – but not the sort of place to run out of milk!

A Room with a View,
Saunders Waterford
140 lb Rough,
50 × 75 cm (20 × 30 in)

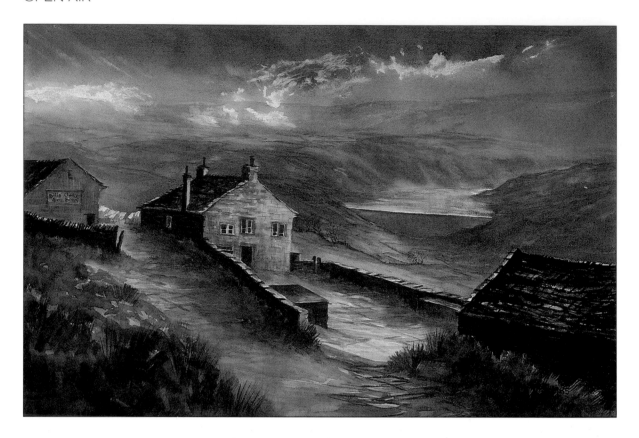

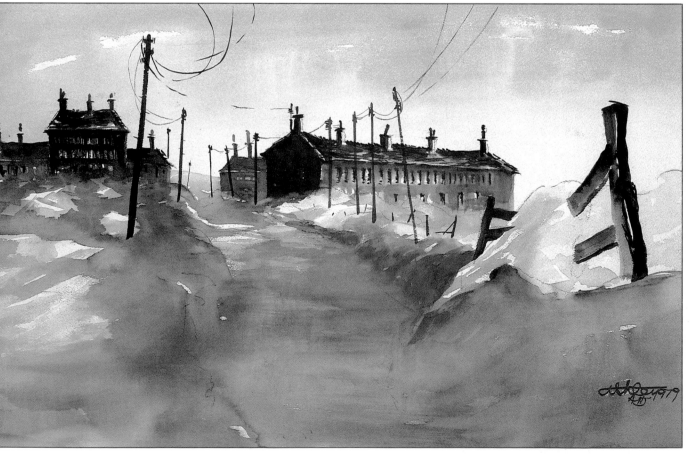

OPPOSITE: *Bill's O'Jacks*,
Saunders Waterford
140 lb Rough,
50 × 75 cm (20 × 30 in)

RIGHT: *Woman on Bike,
Penang*, Saunders
Waterford 140 lb
Rough, 50 × 75 cm
(20 × 30 in)

OPPOSITE BELOW: *Heavy
Going*, Saunders
Waterford 140 lb
Rough, 50 × 75 cm
(20 × 30 in)

Bill's O'Jacks

Recently pulled down, this famous, isolated pub overlooking Saddleworth Moor in Yorkshire was a place of intrigue, having been the scene of at least one murder and where, supposedly, Hindley and Brady, the Moors Murderers, planned their gruesome deeds. I wanted to capture in my painting the satanic qualities of this inn and the grim landscape around it. In order to create the forbidding atmosphere I used Prussian Blue and Burnt Sienna, with a hint of Crimson Alizarin, as my key colour. This gave a cold and sombre feeling to the painting.

Heavy Going

This winter scene was painted at Four Lane Ends near Emley Moor, South Yorkshire. I have often described moorland landscapes as 'frozen seas', because the contours can resemble the waves of a choppy sea. When the snow falls, these contours are exaggerated as it drifts. I like the isolation snow brings to a scene and the special atmosphere that it creates.

Woman on Bike, Penang

I was sitting in a dinghy enjoying the peace and tranquillity of this scene when suddenly I was startled by the appearance of this woman on her bike. I rarely feature people in my work, but because she had intruded on my solitude so unexpectedly I thought I had better put her into this painting.

Open Moorland (overleaf)

In this painting I have tried to capture everything that nature has to offer in the simplest of terms. The economy of line is the essence of this painting. It is pure atmosphere, unembellished in any way: not easy to create, but when it works, it's pure magic.

OVERLEAF: *Open
Moorland*, Saunders
Waterford 140 lb
Rough, 50 × 75 cm
(20 × 30 in)

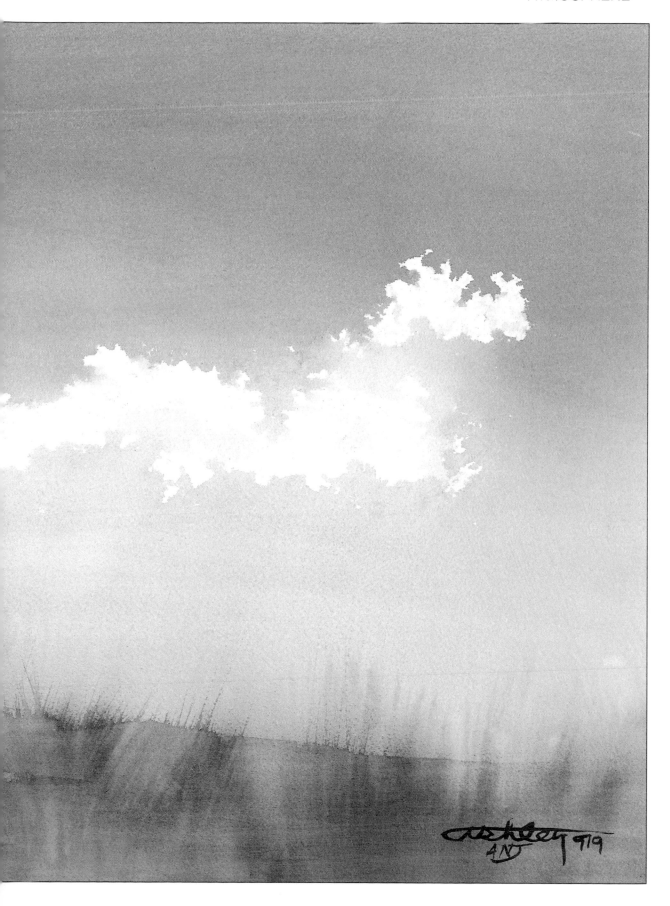

Fig. 76 Preliminary
drawing

BELOW: **Fig. 77**
Stage One

BELOW RIGHT: **Fig. 78**
Stage Two

BELOW FAR RIGHT: **Fig. 79**
Stage Three

The Long and Winding Road
When I first came upon this view it
intrigued me, because the best composition
as a whole involved painting only the gable
end of the house. I challenged myself to
paint it as I saw it, without making the
house look like a cardboard cut-out.

Colours and paper used: Prussian Blue,
French Ultramarine Blue, Crimson Alizarin,
Burnt Sienna, Cadmium Yellow, Raw
Sienna and Lemon Yellow; Saunders
Waterford 140 lb Rough.

Drawing
I lightly drew in the walls in the foreground,
which lead into the picture, and outlined the
gable end of the house. I left out the horizon
until I began to paint.

Stage One
Starting as usual with the sky, I mixed the
two blues, using about 70 per cent Prussian
Blue, and with a large wash brush applied
the colour to the top third of the sky area. I
used the 'windscreen wiper' technique,
allowing the colour to get weaker as I pro-
gressed. I then mixed Cadmium Yellow and

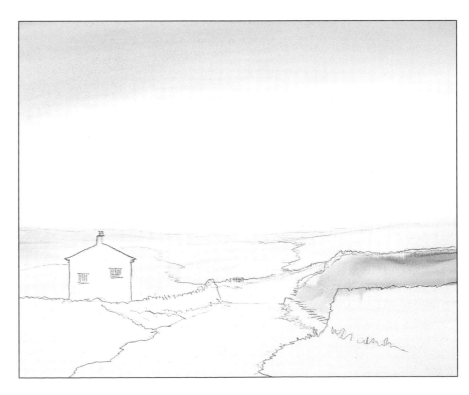

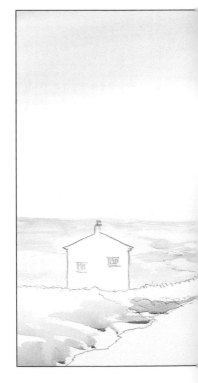

Raw Sienna, and with the same brush added a wash in a similar way to the lower two thirds of the sky. This created a warm, mid-morning glow. I left a small gap between the two washes so that the colours did not merge. I then emphasized the difference between the two sky colours by softening the edges of both washes. Once the initial washes had dried, I started to work on the hills in the distance, using a mix of French Ultramarine Blue and Crimson Alizarin, and adding a very small amount of Prussian Blue as I moved forwards. I applied a foundation wash of Cadmium Yellow and Raw Sienna to the middle distance and then painted the field on the right with a mixture of Cadmium Yellow, Prussian Blue and a hint of Lemon Yellow, using horizontal strokes of a large detail brush.

Stage Two

Next, I applied a second wash to the distant hills, using the original colour and this time shaping walls and gullies. I also applied a second wash to the hills in the middle distance, giving them more contours and shape. I then mixed Prussian Blue, Lemon Yellow, Cadmium Yellow and Raw Sienna, and started to work on the tufts of grass in the foreground, on either side of the road. I used the side of a medium detail brush to create the effect of grass tufts with a flicking motion.

Stage Three

With a medium detail brush, carrying Prussian Blue and a small amount of Burnt Sienna, I drew in the detail of the walls in the middle distance as though I were using a pencil. I concentrated next on the foreground walls, using the same brush and the same colours, but with more pigment and less water. On the right-hand wall, I put in some detail, cutting in the spaces between the stones so that when the final wash was applied it would still be evident that the wall is made up of individual stones. I then applied another wash to the grass verge in the foreground in order to build up colour and depth.

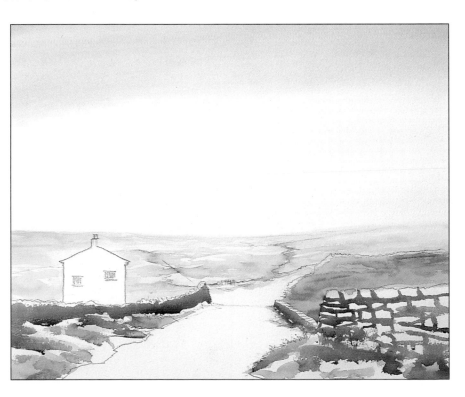

Final Stage

At this point I began to paint the gable end of
the house, using Prussian Blue, Burnt
Sienna and a touch of Crimson Alizarin, and
leaving white areas for the windows. With a
wash of the same colour I covered the fore-
ground, walls and grassland to add strength,
perspective and atmosphere to these areas,
making the painting instantly more dra-
matic. I then cut in stones on the wall tops,
which have the effect of leading your eye
down the road and into the distance. I left
the tops of the walls white to reflect light
from the sky.

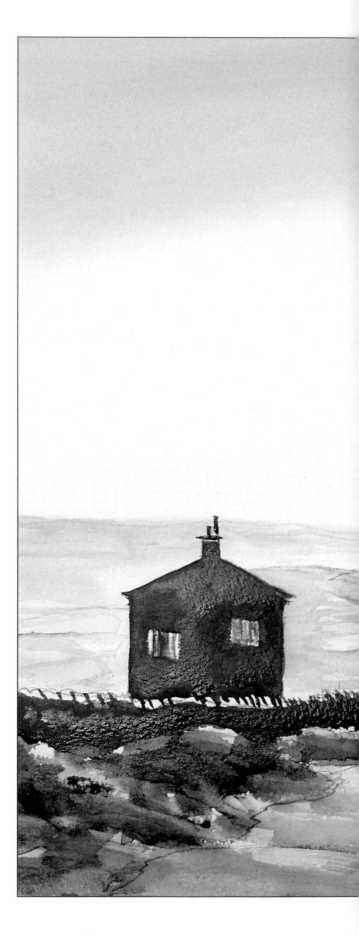

Fig. 80 Final Stage: *The
Long and Winding
Road*, 50 × 75 cm
(20 × 30 in)

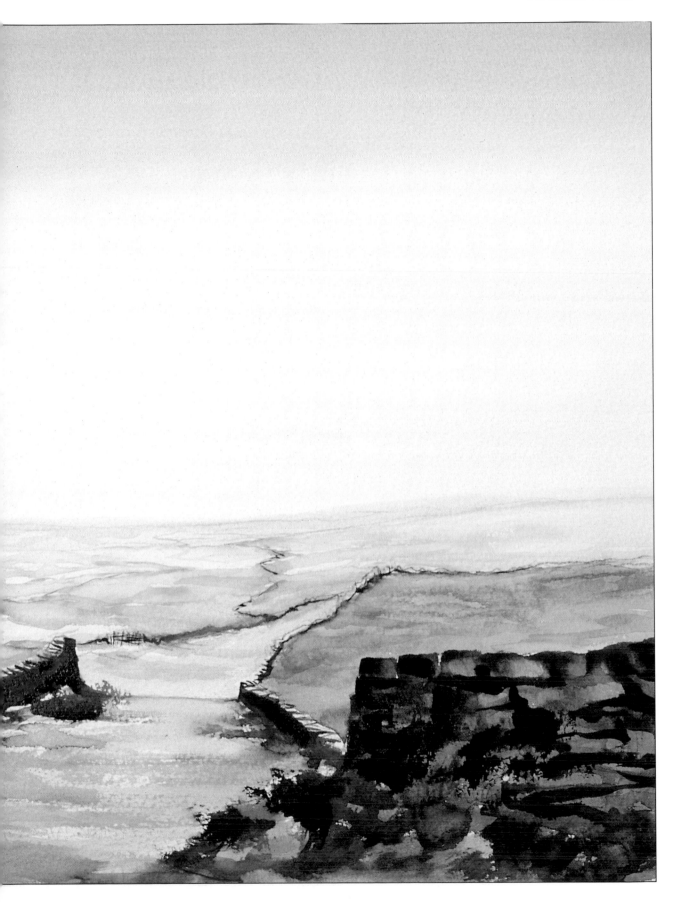

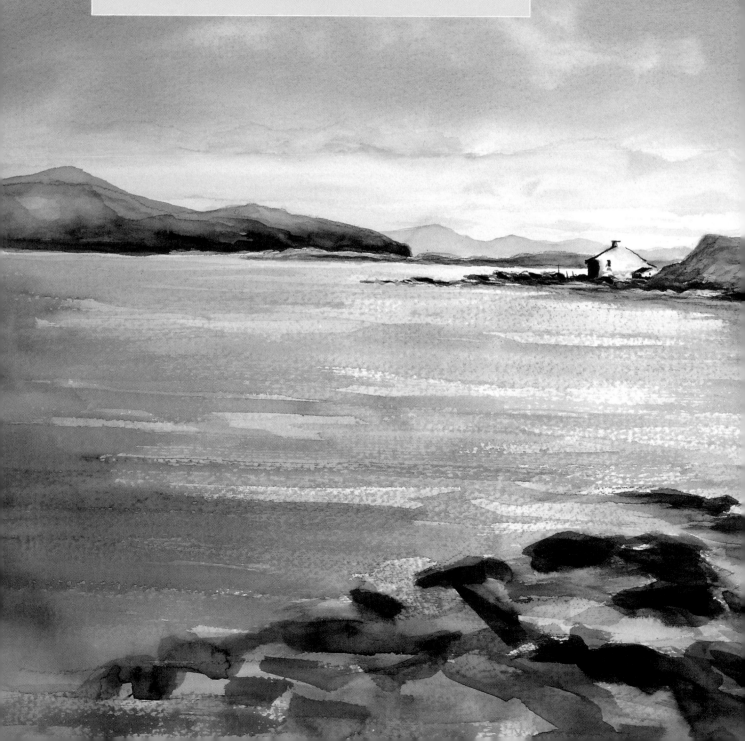

10 THE ARTIST'S GALLERY

This section includes a number of my watercolour paintings, all of which were painted in the open air. I hope you will enjoy looking at them and that they will inspire you to take up the challenge of painting in the great outdoors.

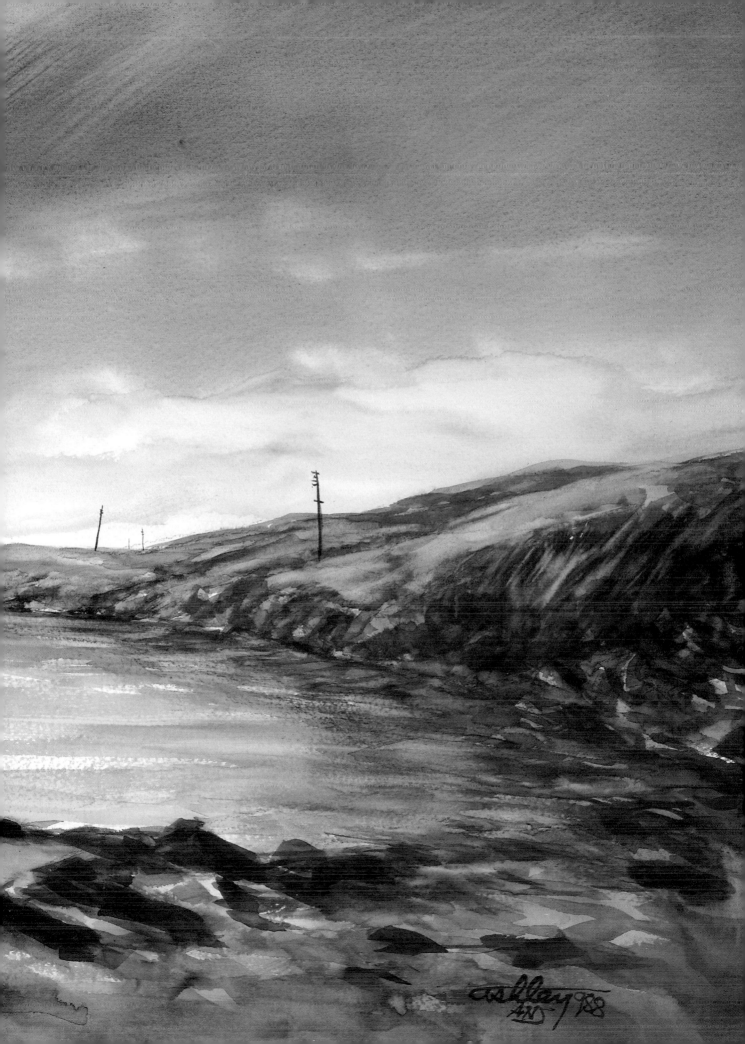

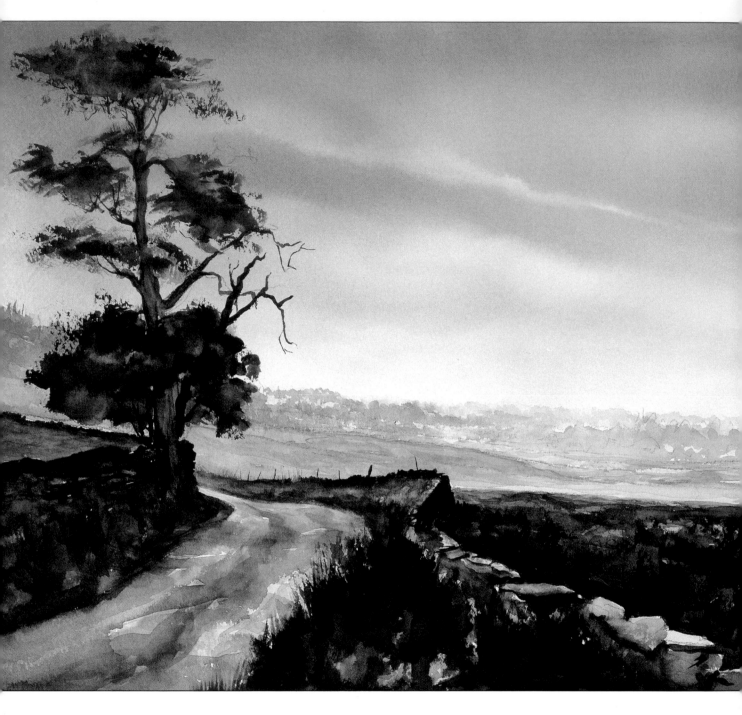

All the paintings in the
Gallery were painted
on Saunders Waterford
140 lb Rough paper and
measure 50 × 75 cm
(20 × 30 in)

PREVIOUS PAGES: *At Peace
with the World, Isle of
Skye*

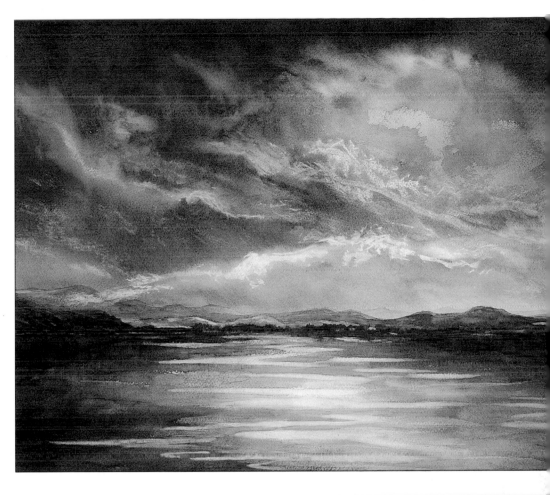

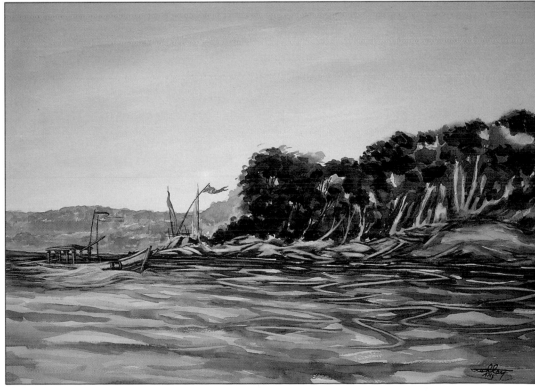

ABOVE: *Tranquillity in Farndale, North Yorkshire*

ABOVE RIGHT: *Wild Sky, Morecambe Bay*

RIGHT: *Homage to the Sea Gods*

*Hannah Hauxwell's
Farm*

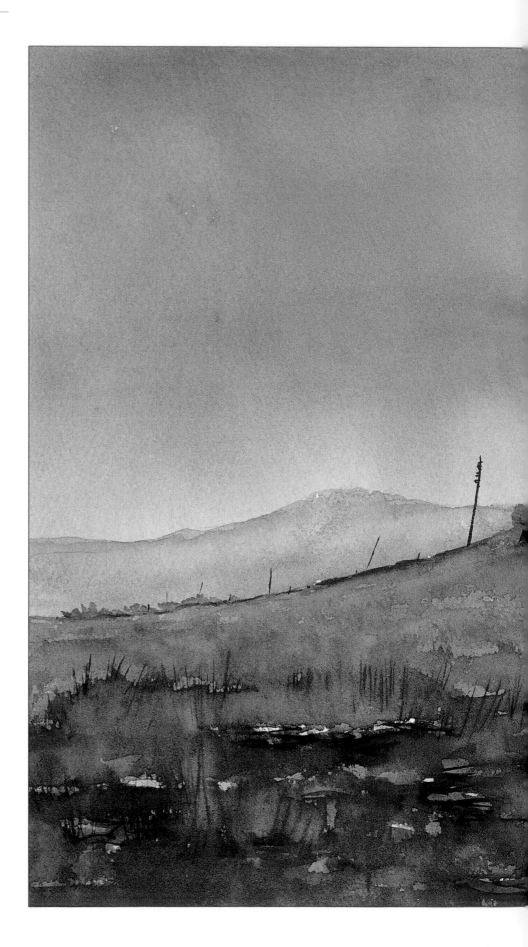

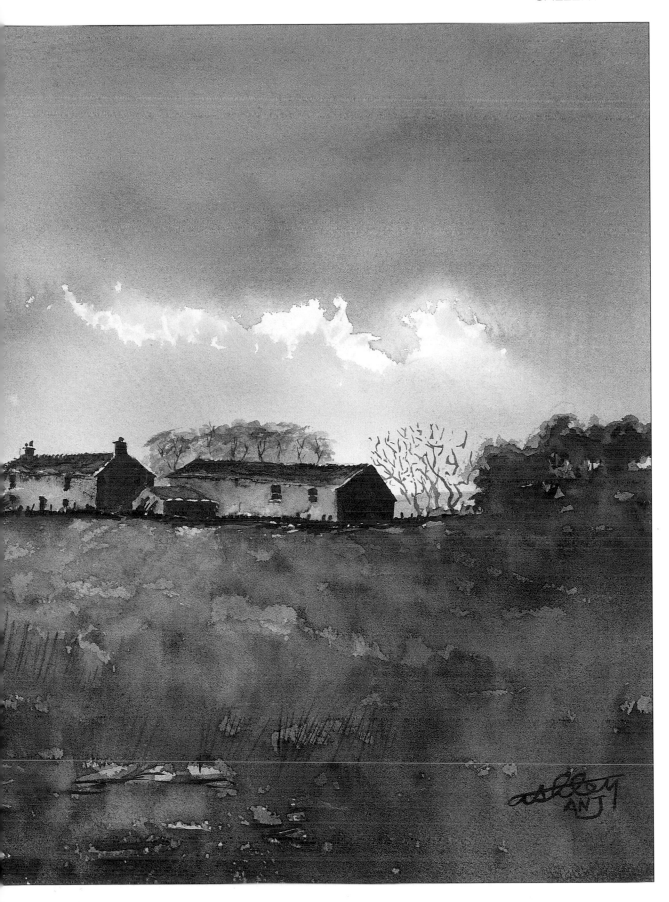

Electric Atmosphere

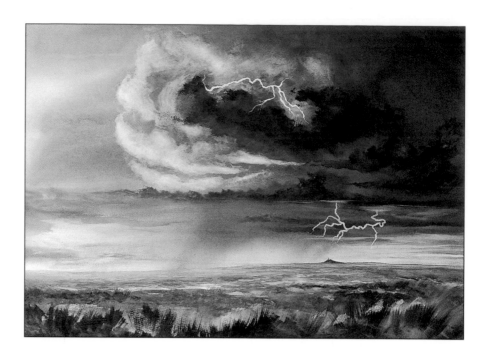

BELOW: *Broken Light,
Hornby Castle from
Tatham*

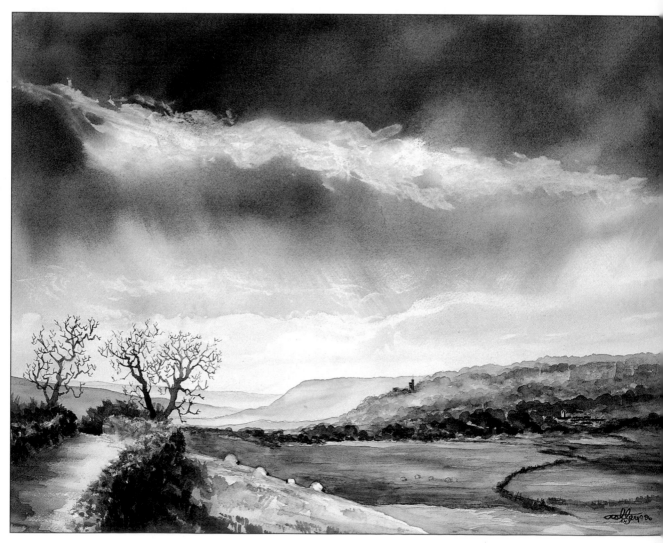

Spotlight on the Moor

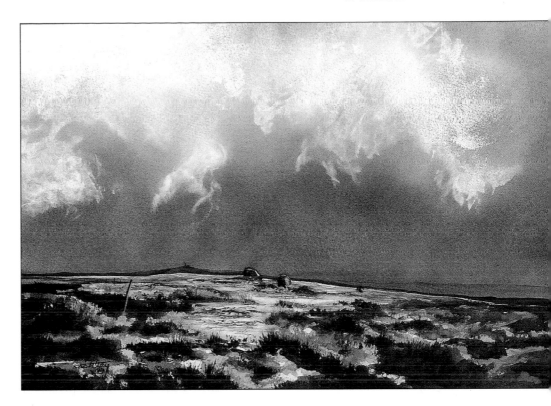

BELOW: *Isolation High on
the Moor*

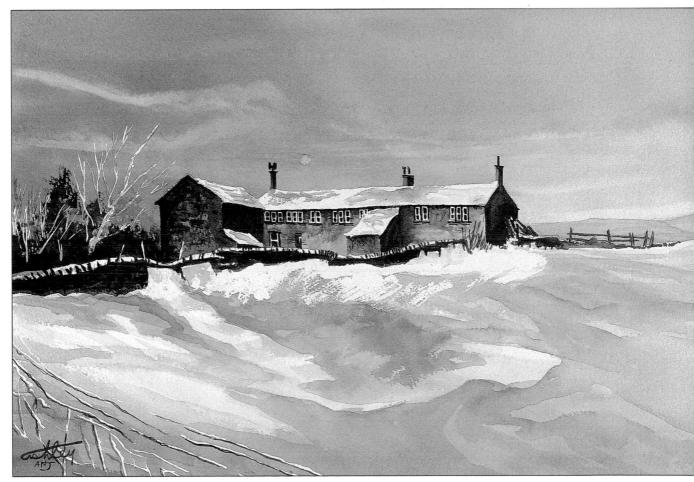

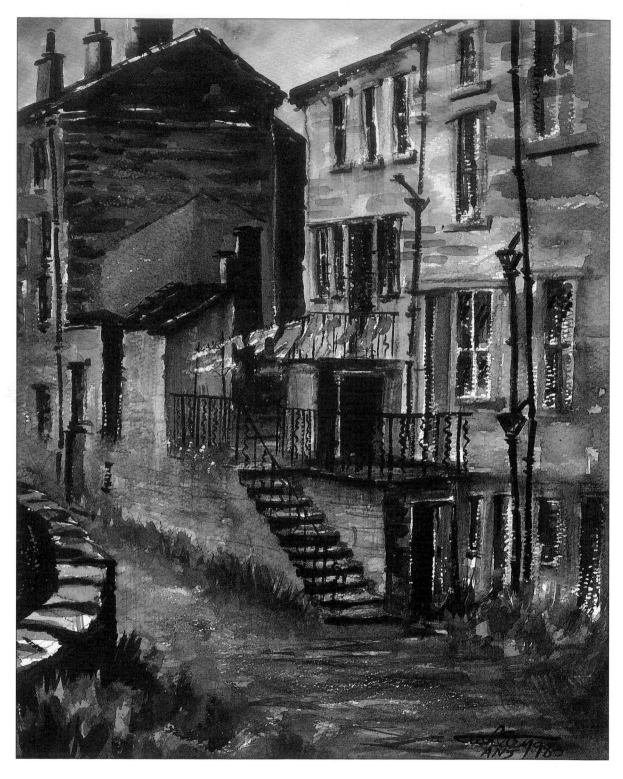

Nora's Quiet Corner,
Holmfirth
(By kind permission of
Cathy Staff)